SECRET DUNDEE

Gregor Stewart

AMBERLEY

First published 2018

Amberley Publishing
The Hill, Stroud
Gloucestershire, GL5 4EP

www.amberley-books.com

ISBN 978 1 4456 7843 6 (print)
ISBN 978 1 4456 7844 3 (ebook)

British Library Cataloguing in Publication Data.
A catalogue record for this book is available from the
British Library.

Origination by Amberley Publishing.
Printed in Great Britain.

Contents

Introduction

Sitting on the banks of the Tay Estuary on the east coast of Scotland, Dundee is today the fourth largest city in Scotland, with a population of around 148,000 people. The city can trace its origins back to the Pictish times, when a settlement began to grow around a natural harbour within the mouth of the Tay Estuary. It would not, however, be until the thirteenth century that Dundee would come into prominence, as the position and protection offered by this harbour grew in importance. The growing demand from the shipping industry brought employment to the area and the town subsequently grew to cater for this. The key location allowed the Dundee shipping industry to trade with the ports of the Baltic Sea, France and Spain, trading links that would lead to some of the aspects Dundee is most famous for.

Where there is success, there are also threats, and in the sixteenth century the port of Dundee was attacked by an English fleet. By this time, the town was already in the early grips of the Protestant Reformation that would bring destruction throughout the whole of Scotland. In the seventeenth century, Dundee would once again suffer, initially at the hands of the Royalist forces and later from the invading forces of Oliver Cromwell's New Model Army. Extensive damage was caused throughout the area, yet despite it taking around 100 years, Dundee recovered and rose again through the importance of the shipping industry, once again becoming a major import and export port. The knowledge gained through the whaling industry of the seas around the Nordic countries and in the construction of ships to withstand the freezing conditions led to Dundee becoming an important city in the exploration and mapping of this area.

The city continued to expand into the nineteenth century, and while it was affluent for some, the majority of the townsfolk lived in absolute poverty. With average life expectancies being among the shortest in the country, improvements were gradually brought in, with gas lighting, a piped fresh water supply and a main sewer being introduced. Horse-drawn trams later allowed people the opportunity to live further away from their place of work, easing the overcrowding, and parks were established to provide leisure facilities, vastly improving conditions in the city. The introduction of the railway would further expand the influence of Dundee, and the resultant transport links brought people and business to the city.

In 1929, the Wall Street Crash in America would have devastating effects across the world. With American banks calling for the repayment of loans to other countries to try to bring some money into the country, and bans on imports that adversely affected the global shipbuilding industry, Dundee was particularly badly hit. Yet, after the Second World War the people of Dundee were to once again show their resilience in the face of adversity, and the city adapted to accommodate the growing technological revolution. The skilled workforces were able to quickly adapt to the intricate work required and the city once again worked its way out of poverty.

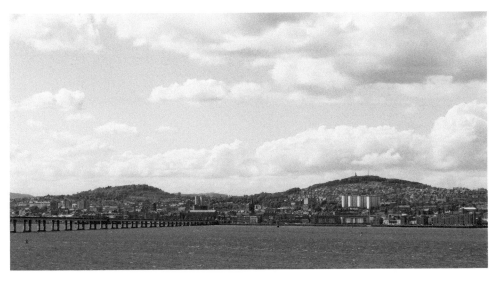

General view of Dundee from across the River Tay.

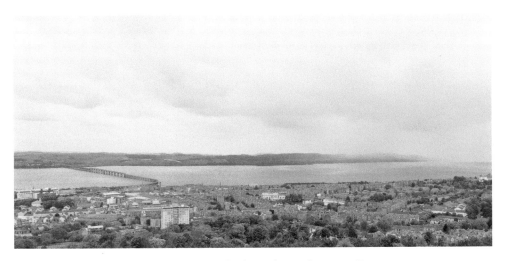

General view of Dundee from The Law, looking down the River Tay.

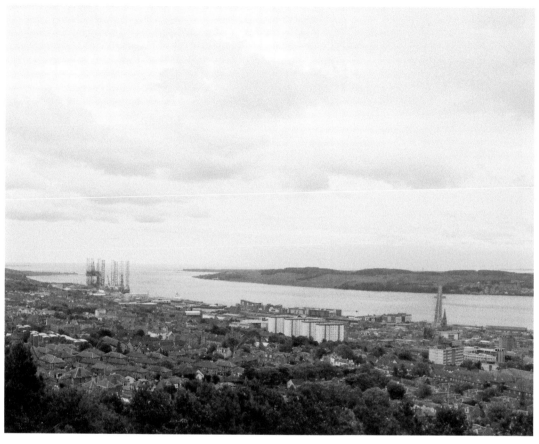

General view of Dundee from The Law, looking out to the North Sea.

1. The Origins of the City

While the exact age of the original settlement that would grow into Dundee is not known, it is evidenced that people lived in the area and worked the land as far back as the times of the Picts.

The dates for the Pictish period in Scotland are one that no certainty can be given. No written records exist of the Picts and what we do know about them is mainly based on the writing of the Roman forces. Given that they were trying to invade Pictland and defeat the Picts, it is reasonable to expect that Roman accounts do not necessarily reflect favourably on them. They are first mentioned in documents written in the year AD 297 by the Roman writer Eumenius. The name 'Picts' is widely believed to have been allocated to them by the Romans, with it meaning 'the painted ones', a reflection of the battle paint they wore. There is, however, also a suggestion that the name comes from the word *pecht*, meaning 'the ancestors'. Although often referred to as a single group of people, the Picts were not in fact a single tribe. Instead they were a collective of a number of small kingdoms, who each operated separately, yet came together when there was a common goal, including defeating enemy invaders. This included not only the Romans, but also the Angles of Northumberland, with it often being considered that it was these battles that first drew the 'North/South divide'.

The kingdom of the Picts extended northwards from the Firth of Forth to the lower Highlands, with the first recorded king of the Picts being Vipoig, who reigned from around 312 to 342. A hill fort is thought to have existed in the Dundee area, with a small settlement establishing on the slopes around it where they would be protected by the fort. It is thought that it was the Romans who first used Dundee as a port during their invasion of the first century, before they were forced back south of the River Forth.

After the Romans left, the Picts faced a new threat from the Angles of Northumbria. In the year 603, the threat was deemed too great to be ignored any longer, and King Aedan gathered an army consisting of both Picts and Scots, and marched against the Northumbrians. It was a huge mistake, and King Aedan's forces were defeated and his two sons killed. What happened to the king is not recorded. In retaliation the Angles pushed forward, and soon the lands south of the River Tay were under their control. The Angles were literally knocking on Dundee's door.

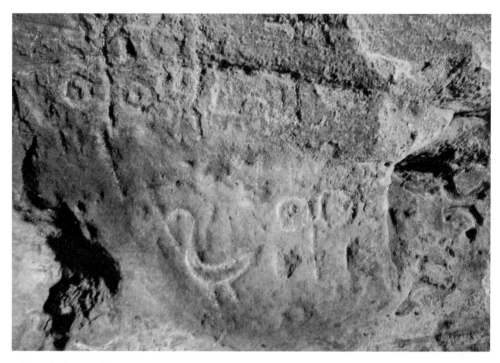

Above, below and opposite page: Pictish carvings from the Wemyss Caves near Dundee. Carvings such as these are the only known written communication used by the Picts.

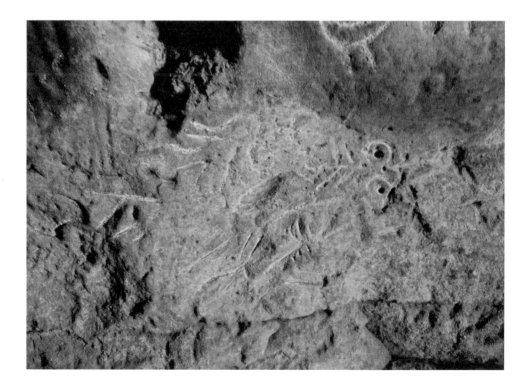

While great leaders such as Robert the Bruce and William Wallace are well documented in history, an equally as important leader emerged to do battle against the Angles. After their defeat in the failed attempt to invade Northumbria, the Picts had turned to a new leader, Bridei. King Bridei demonstrated his skills on the battlefield through both well-planned tactics and brutality, and he successfully took control of large parts of the Pictish lands in the north of Scotland. With the advancing forces of the Angles from the south, he knew it would only be a matter of time before they reached his northern territory if they were not stopped. In the year 685 he brought his army to meet the Angles at what was known as the Battle of Dunnichen, fought just north of Dundee. Having been coaxed to advance, King Ecgfrith of the Angles did just that, despite the pleading of his advisors who insisted that with the barren land and high hills and mountains, he was simply exposing his army to attack. King Bridei sent a small group of men out to deliberately be sighted by the invading Angles and, believing them to be the Pictish army, King Ecgfrith pursued them, thinking an easy victory was in sight and he could prove his advisors wrong. Instead, he played right into the hands of the Picts, and as they came over the summit of a small hill near Dunnichen Hill the Angles came face to face with the full Pictish army. The site for the battle had been carefully chosen with a loch and hill restricting any opportunities to retreat. The resulting battle was swift and decisive, with the Northumbrian forces being slaughtered. The impact of the battle would change Scotland significantly. The Northumbrians power was significantly reduced and they withdrew, returning the Pictish frontier to the River Forth. Over time, the Northumbrian forces were swallowed up by the emerging kingdom of England and the Picts entered into a period where the individual kingdoms united under one ruler, King Bridei. A bizarre twist to the story, yet not uncommon at these times, is that the mortal enemies King Bridei and King Ecgfrith were actually cousins, yet both sought to destroy each other.

DID YOU KNOW?
According to legend, the first church in Dundee was founded in the year 431. This was to be the first church north of the River Tay, and is believed to have been at the Invergowrie end of the current city.

By the eighth century, Scotland remained a divided country, with the largest regions being controlled by the Picts from the River Forth northwards, and the Scots on the west coast. The Picts were under constant threat from the Scots and

also found themselves under attack from the north by Vikings. In the year 831, King Alpin succeeded to the Scots throne and mounted a battle against the Picts. King Brudus marched his army from his Pictish kingdom of Dunkeld, before finding the Scots army camped at Dundee. Seeking to use the surrounding hills to his advantage, King Brudus ordered all attendants, including the women, to take horses and position themselves where they could be seen on the hilltops. The tactics worked, as when the battle followed the Scots army saw the figures both standing and on horseback all around them and, fearing they were surrounded, they began to panic and flee. King Alpin tried but failed to regain order, and his army was defeated. King Alpin and his commanders were all taken prisoner. The commanders were slain on the battlefield, with King Alpin being bound and held. There are some references to earlier history books that a ransom was demanded but it was refused. Regardless of which version of the story that is relied upon, the end result is the same: King Alpin was beheaded at a place that the subsequently bore the name Pitalpin, signifying the death of Alpin. It is widely believed that the execution took place around Camperdown.

The Viking invasions continued and saw many of the Pictish nobles and leaders being killed, while King Alpin's son, Kenneth MacAlpin, took his father's place as King of the Scots in Dalriada (an area that lay approximately where modern-day Argyll sits). He too laid a challenge to the Pictish Crown, just as his father had. It was Pictish tradition that the heir to the throne was passed down through the female side of the royal families for the rather crude reason that while the identity of the father could never be known for sure, the identity of the mother could not be disputed. The basis of King Kenneth's claim was that his mother was a Pictish princess. Just as his father's claim had been disputed, so to was King Kenneth's claim, and he went to battle with the Picts. After winning several battles, King Kenneth is said to have seemingly extended a peace offering to the Picts by arranging to meet with all of those who had claim to the throne at Scone, where it could be debated and the rightful heir agreed upon. It is much disputed whether this actually took place and, if it did, what actually happened. The most common story, probably because it is the most brutal, is that King Kenneth ensured that alcohol flowed freely through the night. In an act that is known as MacAlpin's Treason, he then reputedly brought all to a room where the discussions could take place, but in fact he had booby-trapped the benches. Once all of his opponents were seated, trapdoors beneath were released, plunging everyone down into spiked pits. There was suddenly only one claim to the throne. Whether that story is true, or whether it was through the continuation of his successful battles, King Kenneth took control of the Pictish Crown in 834. His combined kingdoms became known as Alba. As the King of Scots and the King of the Picts, he became known as the first King of Alba, and with Alba later

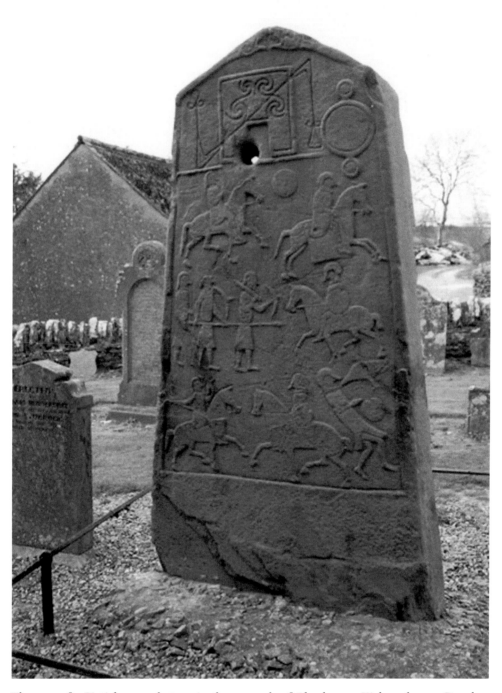

The rear of a Pictish carved stone in the grounds of Aberlemno Kirkyard, near Dundee, is believed to depict the Battle of Dunnichen. (Courtesy of Andrew Wood under Creative Commons 2.0)

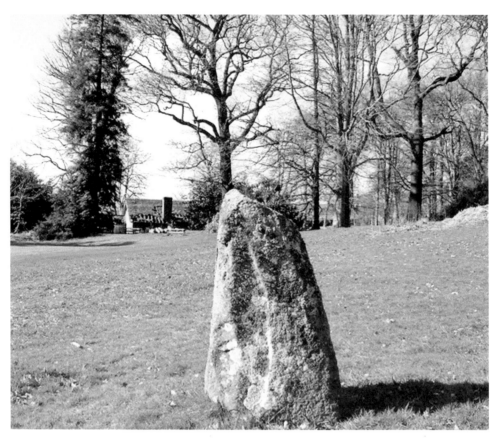

Kings Cross Stone in the grounds of Camperdown House is said by some to be where King Alpin raised the standard to signify the start of the battle, and where he was taken to be beheaded. (Courtesy of Stephen Samson under Creative Commons 2.0)

becoming Scotland, King Kenneth is said to be the first King of Scotland. With the increased forces of the two kingdoms, King Kenneth took a united battle to the Vikings and began to force them to retreat.

DID YOU KNOW?
On 29 September 1842 it was reported in the press that during digging works at the mound of Pitalpin, close to where the Kings Cross Stone stands in the grounds of Camperdown, a headless skeleton was found. It was widely believed that these were the remains of King Alpin, and the bones were gathered and taken to the Watt Institution in Dundee.

2. The Growth of the City

By around 1180 the town of Dundee had become well established and with the port of Dundee trading in wool, sheepskins and cattle hides with the Continent, the town was granted the status of a 'burgh' by Earl David, son of William I, in the later part of the twelfth century. Ports in these times were far more important for regional trade than now. There was no significant road network, and transporting anything across land was both dangerous and time consuming. Ports offered the ability to load goods onto a ship and take them even a short distance to the next city – much quicker and without the risks.

In 1199, the merchants of Dundee were granted a charter by King James of England that allowed them free trade throughout England, with the exception of the City of London. This was a substantial boost to Dundee, considerably increasing the markets it could serve, and by the early thirteenth century a small harbour had been built. This charter is frequently referred to as Dundee's oldest document (even though the original has in fact been lost) and gives an indication that Dundee would have had a substantial fleet at this time – for the simple reason that if the merchants did not have the facilities to trade with England, then there would be no point in issuing the charter. It is more likely that ships from Dundee were already trading throughout England and the charter was issued to make that trade free of tariffs, which also allowed the English ports the opportunity to trade through Dundee to wider markets in the north.

In 1209, William I of Scotland made Dundee a royal burgh, which bestowed privileges and powers to the people, including establishing their own associations to levy taxes and removing the right to trade in certain good, which the merchants took full advantage of to boost their own self interests.

Dundee did have a castle, which is widely accepted to have stood at the top of Castle Street, around where St Paul's Cathedral is now situated. Details of the castle are very scant. There are records that a palace was to be built in Dundee around 1071 for Malcolm III, yet it is not clear whether this was the castle or if the castle later replaced this palace. I have not been able to find any documentation to confirm whether this palace was in fact built. The castle is, however, mentioned in records from 1290, and so it was certainly in existence at that point.

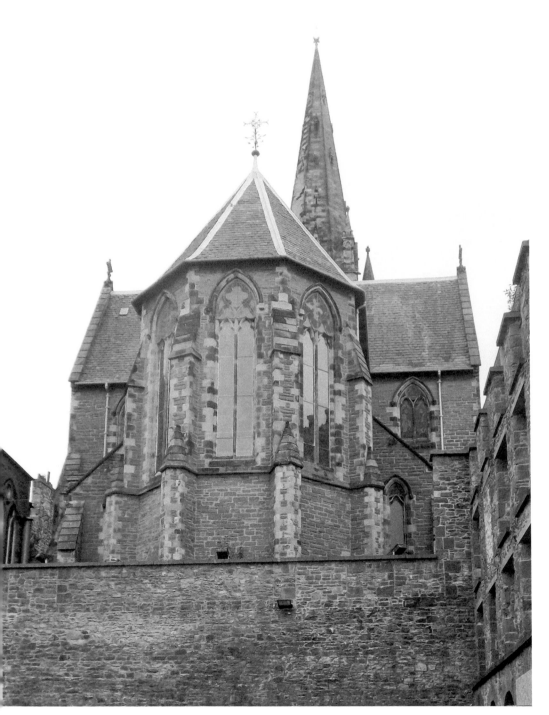

St Paul's Cathedral, believed to be built at least partially on the site of the original Dundee Castle. (Courtesy of Stanley Howe under Creative Commons 2.0)

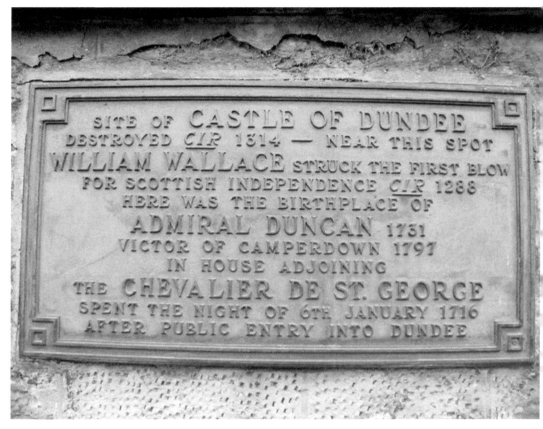

Memorial plaque at the site of Dundee Castle. (Courtesy of Kim Traynor under Creative Commons 2.0)

In 1291, one of Scotland's most famous warriors became connected to Dundee. William Wallace was educated in Dundee in a church-run school. When Edward I of England effectively took control of Scotland as overlord of King Balliol, he placed soldiers in every castle, including Dundee. Whether fact of fiction, the story goes that while playing sport in the Westport area of the city, Wallace was approached by the son of the governor of the castle – named Selby – who berated him as he was wearing the colour green, which should only be worn by gentry. The two young men argued and it first became heated before turning violent. Wallace was carrying a dagger, which he drew and killed his opponent. The authorities were quickly alerted to what had happened, and Wallace was chased along Hawkhill and the Perth Road. After running for around 6 miles, the exhausted young man rested on a grinding stone at a small cottage around Longforgan. The farmer's wife found him and took him inside, where she heard what had happened. Knowing the English authorities would be hot on his tail, she gave him clothing

to disguise himself as a woman and he started to work at the spinning wheel just as the English forces arrived. Remarkably, it worked, and it seems that, other than a cursory search, the authorities were content with the assertions of the farmer's wife that she had not seen anyone and they continued their pursuit towards Perth. Wallace remained disguised until nightfall, when those loyal to his family took him under the cover of darkness to stay with his uncle at Kilspindie in the Carse of Gowrie. He stayed there for a few days, before being moved from safe house to safe house. If the story is true, this would be the first kill of William Wallace, and the start of his campaign against the English overlords.

DID YOU KNOW?
Around 1190, David, the Earl of Huntingdon and brother of King William the Lion, suffered numerous disasters while escaping a failed crusade. He is said to have asked for the aid of heaven, vowing to build a church to the honour of the Virgin Mary if he was permitted to land safely in his home country. The raging sea around him became calm and the Dundee Law then became visible to him, and he safely landed at a rocky crag, thereafter known as St Nicholas' Crag.

After King Balliol crossed King Edward, the English forces invaded in 1296. Dundee was particularly harshly treated. Having heard stories of the barbarous methods of Edward's army, a large number of Dundee's residents sought shelter in a church, feeling they would be safe there in the house of God. When Edward's forces arrived, the empty houses were ransacked before he ordered the church to be set alight, burning all inside alive. This particular act of savagery awoke a rebellion in Scotland, and the nobles began to fight back, with William Wallace once again returning to battle. Wallace returned to Dundee, to revisit the place of his first kill and to take the city back from the English, but as he prepared to attack he received word of the English forces marching towards Stirling. He gathered his troops and headed to lead the now famous Battle of Stirling Bridge, a decisive victory against the English that sent shockwaves throughout the entire English army. He swiftly returned to Dundee and on seeing his forces approach and having received word of what had happened at Stirling, the English surrendered both the town and castle in exchange for their lives.

Wallace went on to further battles and an English captain named Morton once again seized Dundee Castle for the English. When Wallace returned from his campaign in England and heard that Dundee was once again in the hands of the English, he laid siege to the castle. Morton offered to surrender in return for his life, just as the earlier English forces had, but this time the offer was rejected. Before the castle could be retaken, word reached Wallace that King Edward's army was once again marching north so he departed, leaving part of his forces under the command of Alexander Schymeschur, who successfully retook the castle. Morton was captured and taken to Perth, where on the orders of William Wallace, he was hung. For his loyalty, Alexander Schymeschur was appointed Constable of Dundee and it was ordered that Dundee Castle be demolished to prevent it being taken by enemy forces again.

This would not be the only famous name from Scottish history to be influential in the growth of Dundee. Under the reign of King Robert the Bruce, the English forces had once again taken the city. Bruce sent his brother, Prince Edward, to free the city. After victory at Bannockburn and the reestablishment of the Scottish monarchy, King Robert went on to stay in Dundee for some time. The burgesses of the city took this opportunity to plead directly with him that their rights under the charters earlier issued had been lost, and in 1326 all rights were returned.

Despite the battles with the English, the thirteenth century also saw the establishment of friaries in Dundee, with the distinctive Dominican Black Friars being notable. The name was derived from the black cloaks they wore, but what set them aside from other religious organisations was that, instead of expecting people to come to them to worship, the Black Friars went out among the people to preach and would extend assistance to local people, including sharing fishing rights.

After the re-establishment of the charters to the town, Dundee's importance once again grew as a major commercial port. By the mid-fourteenth century it was considered to be one of the most important towns in Scotland, with a population of around 4,000 people. This may not seem a lot by today's comparisons, but in the fourteenth century it marked a substantial settlement.

DID YOU KNOW?
Dudhope Castle in Dundee was constructed in the thirteenth century to provide accommodation for the hereditary constables of Dundee and their family. The current castle was rebuilt in the sixteenth century.

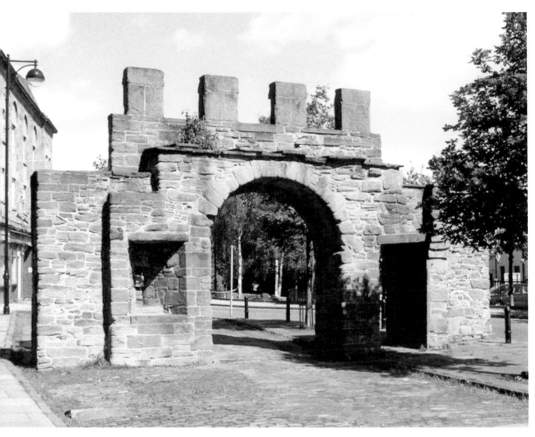

The East Port in the Cowgate is one of only two surviving burgh gateways in Scotland and once formed part of the walls that surrounded Dundee. (Courtesy of Kim Traynor under Creative Commons 2.0)

3. The Protestant Reformation in Dundee

The Protestant Reformation brought mass killing and destruction across Scotland, but before examining its effect on Dundee the religious position of the country requires to be outlined.

The first signs of religious unrest came to Scotland during the sixteenth century. Protestant preachers were travelling across Europe and countries were beginning to convert. With the European preachers – known as the Fathers of the European Reformation – travelling across the Continent, the rulers of Scotland knew it was only a matter of time before word of their ways would reach the country's shores. Determined that Scotland would remain a Catholic country, any attempt to convert to the Protestant faith was to be stamped out in its infancy. A young man named Patrick Hamilton was the first to fall foul of the Scottish authorities. He had heard the preaching of Martin Luther while travelling in Europe before returning to Scotland to study at St Andrews University. With the university being established through the religious importance of the town, the enthusiastic yet naive young man was keen to start to talk about what he had heard in Europe. It is unlikely he realised the potential consequences of his actions, but all became clear when Dr James Beaton, Archbishop of St Andrews and leader of the Catholic Church in Scotland, heard. Promoting the Protestant faith in a town that widely known as Scotland's equivalent to Rome was not the best idea. The archbishop ordered the arrest of Patrick Hamilton, but the student was tipped off and he fled back to Europe before he could be captured.

For unknown reasons, he soon returned to St Andrews to continue with his studies. Perhaps it was a scheme put in place by Archbishop Beaton, who initially seemed to raise no objections to Hamilton talking about and even preaching the Protestant faith. Once Hamilton seemed relatively settled back he was invited to the archbishop's castle to discuss the new faith, an invite he willingly took up, yet there could be little doubt he knew it was a trap. As soon as he entered the castle, he was arrested. What was nothing more than a show trial followed, and Hamilton was sentenced to be burned at the stake. On 29 February 1528, at the age of just twenty-four, Patrick Hamilton was chained to the stake above a small pile of wood in front of St Salvator's Chapel in St Andrews. Despite the pleadings of his friends he refused to deny his Protestant beliefs, an act that would have at least afforded him the small mercy of being strangled to death before the fire was

lit. What followed was horrific, even for those barbarous times. Wet wood was used, so the fire had to be rebuilt and relit several times, with Hamilton suffering severe burns each time. His ordeal lasted six hours before he died.

The botched execution did Archbishop Beaton no favours. Having witnessed the torment and agony of a friend for nothing more than having different religious beliefs, more and more started to turn away from a Catholic faith that could treat people so badly. Realising the levels of unrest, John Lindsay, a close friend and advisor of Archbishop Beaton is said to have sent him a letter warning him, 'If you burn any more you will utterly destroy yourselves. If you will burn them let them be burnt in deep cellars, for the smoke of Patrick Hamilton has infected as many as it blew upon.' The future archbishops should have taken heed of that warning.

In 1532, Henry Forrest was found to be in possession of a copy of the New Testament. For this, he too was burned at the stake. Many reports state that he was burned on the high ground above St Andrews Harbour, to ensure the flames would be seen across the water in Dundee and send out a warning to others to stay strong with their Catholic beliefs. The country was divided, but as the persecution of the Protestants became more and more swift, the strength of the Protestant movement strengthened, fuelled by the barbarity of the Catholics. In 1539, Cardinal David Beaton succeeded his uncle as Archbishop of St Andrews and the levels of cruelty against the Protestants increased under his command. His actions led many to believe he was in league with the Devil himself. Yet Cardinal Beaton held not only the highest position in the Scottish Church, he was also a trusted advisor of James V, so few dared speak out against him. Having failed to seize control of the country after the death of the king (by producing false documents claiming that the king had wished him to be appointed as regent to his infant daughter) Beaton turned his attention – and no doubt his anger – back to the Protestants. In 1546, the actions against another reformer named George Wishart would prove to be the deciding factor in the demise of the Catholic Church in Scotland.

By this time, England had already converted to the Protestant religion, and Wishart had spent time there learning about it. Upon his return to Scotland, he quickly built a following and Cardinal Beaton initially sought to stop him by having the authorities constantly move him from town to town. His constant expulsions only served to increase his popularity: people were interested to hear what this preacher had to say that was so bad the authorities didn't want anyone to hear. Eventually Beaton acted and Wishart was arrested and brought to St Andrews Castle. His trial was held in St Andrews Cathedral, which was really just a number of Catholic leaders telling Wishart the error of his ways. Having been found guilty of heresy, he was taken from the cathedral to be burned at the

St Salvator's Tower in St Andrews, in front of where Patrick Hamilton was burned alive.

The inscription in the pavement marking the spot where Patrick Hamilton was executed.

stake in front of St Andrews Castle. It seems Cardinal Beaton knew that many of the gathered crowd were supporters of Wishart as he had the condemned man escorted by around 100 guards to the place of execution. Yet, in his arrogance, he did not seem to foresee that subjecting another reformer to the agony of being burned at the stake surrounded by his supporters would only increase the levels of hatred against him. A further mistake Beaton made was to watch the execution while lounging in the luxury of his personal apartment in the castle – in full view of the crowd.

Less than two months later Wishart's supporters took their revenge. Ten men joined a group of workers entering the castle and, once inside, they forced everyone out and secured the gates. Beaton remained in his apartment, locking himself inside and pleading for his life. Under the threat of the door being set alight, which would have ignited the rest of the room, he eventually opened it and was stabbed to death. A year-long siege followed, with the reformers locked inside the castle and a somewhat lacklustre attempt by the authorities to retake it.

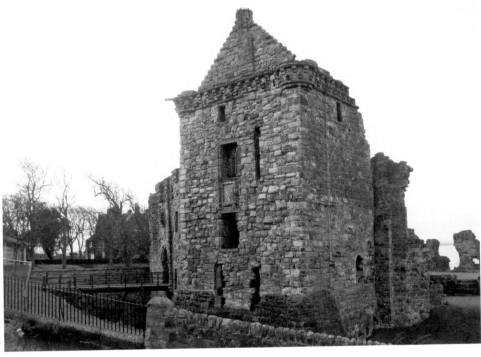

St Andrews Castle looking towards the approximate spot from which Cardinal Beaton watched the execution of George Wishart. The castle has had a new frontage built since then, although the windows remain in the general areas.

The inscription on the road marks the spot where George Wishart was burned alive.

Those inside knew that English forces were once again invading Scotland to try to force the wedding between Mary, Queen of Scots to the son of King Henry. They hoped that when the Protestant king heard what had happened in St Andrews he would send forces to rescue them. The Scots, however, knew that their allies – the French, who remained Catholic – were on their way. It was the French Navy who arrived first. The castle was bombarded from the sea and by canons, which had been hoisted onto high points around the town. The reformers eventually surrendered, but they did so to the leader of the French Navy, denying the Scottish authorities the right to decide their fate. Within the group of reformers was a man named John Knox, a former bodyguard of George Wishart. Knox and the other men served several years working as galley slaves rowing the French ships, until in 1549 the English government aided their release and offered a safe haven.

John Knox continued his preaching in England before returning to Scotland in 1559. The country at that time was still being run by a regent acting on behalf of Queen Mary, who was in France. When the regent fell ill he saw an opportunity and stepped in to convince the Scottish nobles that they should convert and make Scotland a Protestant country. He was successful and, in a powerful sermon delivered in Edinburgh's St Giles Cathedral on 29 June 1559, the true reformation started.

Chaos and destruction followed, with angry mobs showing their rage for all things out on the Catholic Church. Buildings were ransacked and destroyed and ministers forced from their homes.

In Dundee the feelings towards the reformers were strong. George Wishart had in fact preached in the city, and it is reported that it was the enthusiastic reaction from ever-growing audiences in Dundee that caused Cardinal Beaton to start to plan his capture and execution. As he finished a sermon, under the instructions of Cardinal Beaton, Wishart was issued with legal documents ordering him to pester no one else with his preaching and to leave Dundee. After a short pause to think Wishart added to his sermon, stating that the people of Dundee should remember that if any trouble befalls the town, his expulsion is the cause and the people should turn to God who will help them. His words would have greater meaning than anyone ever could have predicted, as just four days after he left the town the plague hit. In a remarkable show of faith, when he heard Wishart returned to Dundee to pray for the ill and once again began to deliver sermons, asking God to help. The plague by this time had begun to run its course, yet people saw its decline as being thanks to the return of George Wishart.

In 1559, Dundee and Perth both announced they were Protestant towns and notices were served on the monks of the monasteries to leave or be forcibly evicted. The destruction, however, still followed, with it being said that every single Catholic building in the city was damaged or destroyed, with stained-glass windows depicting the saints being smashed and stone effigies of the saints being

St Mary's Church and the Old Steeple Church had been extensively destroyed by fire just prior to the Reformation taking hold. The church was rebuilt as the first reformed church in Dundee.

pulled down. In 1565, Mary, Queen of Scots stayed in Dundee for two days and was shown considerable hospitality. During her visit she gifted a number of the former Catholic establishments, along with their possessions, to the magistrates and town council to be used for the benefits of the townsfolk. She also gifted the cemetery of the Franciscan friars along with their convents and gardens to be used as a burial ground, known by the term 'Howff'.

DID YOU KNOW?
During the Reformation, Cardinal Beaton sent an assailant to murder George Wishart in Dundee. After a sermon, Wishart left and saw his assailant waiting for him with a dagger. Wishart's followers tackled the man, who confessed and pled for forgiveness, which Wishart granted and ordered his followers that he was not to be harmed.

4. The New Model Army

While most people have heard of Oliver Cromwell, his background and influence across the country is less well known. In 1603, James VI of Scotland managed to achieve what monarchs before him had tried and failed – the union of the Scottish and English crowns. Control over the joint kingdoms had been fought over for over a century, yet it was finally achieved peacefully through simple family connections when Elizabeth I of England died. She had been unmarried and had no children, leaving the Crown to pass to the next in line to the throne: her cousin James VI of Scotland, who also became James I of England.

After a century of battles between the two nations, it went without saying that the peaceful unification of the crowns did not go down well, especially when it was the smaller nation inheriting the larger nation's throne. With the kingdoms of England and Ireland already joined, King James became the head of the three kingdoms. One of the biggest issues was differing religious practices between the countries, something that King James sought to also unify. Despite several attempts at his life – the most famous of being the Gunpowder Plot, which is still remembered annually on 5 November – and a turbulent time with the English Parliament, King James made progress, particularly with foreign affairs. When he died in 1625, his son Charles I succeeded him to the throne. He sought to carry on with his father's work to bring some conformity in the religious practices, which brought him into direct dispute both with the English Parliament and with the Scottish Church. In 1629, he took the unusual step of abolishing the English Parliament and he continued to rule without it. The growing religious sector in Scotland known as the Covenanters, who strongly opposed the king's rule of the Church, resulted in Charles trying to raise an army to forcibly take control. Unfortunately, there was little appetite in England to go to battle with a religious faction in Scotland, and without Parliament he could not request the release of funds to pay for an army.

In February 1639, with what forces he had been able to muster, King Charles marched to face the Covenanter army in what became known as the First Bishops' War. It was short-lived, and just a month later, the king had withdrawn and the signing of the Treaty of Berwick brought a temporary truce between the two sides. King Charles quickly reformed the English Parliament and asked for their backing to once again wage war against the Covenanters. It seems, however, that

Parliament was not so quick to forget the king's earlier actions, and refused to agree. With Charles once again struggling to form an army, the Covenanters took the opportunity to take the battle to him. Having crossed the border into England, they attacked and took Newcastle, forcing the king to once again admit defeat. By now, the English had had enough of their failing king and, realising that there was the same discontent in Scotland, the English Parliament asked for help in overthrowing Charles. The Scots agreed on the basis of a religious settlement in return, and in 1646, faced with a combined army, King Charles surrendered to the Scottish commanders. Any hope for leniency from the Scots was misplaced as he was handed over to the English Parliament and executed the following year.

In the interim period with no king, a new force had risen and established itself in England, led by Oliver Cromwell. By the time King Charles met his fate, Cromwell's New Model Army was the decisive force in England and declared the country to be a republic, to be known as the Commonwealth of England. Scotland, however, proceeded to crown the son of King Charles, also Charles, as Charles II. As a republic, the English Parliament did not recognise the rule of the new king. Cromwell was angered by the Scots electing to crown a new king instead of accepting his position as running the English Parliament, and he took a formidable force north to do battle with the Royalists.

DID YOU KNOW?
When Cromwell's troops pillaged Dundee, a vast fortune was taken, estimated to equate to around £12 billion today. However, as the forces sailed from Dundee in around sixty stolen ships to take the gold coins back to England, a massive storm arose, sinking the entire fleet. Despite several searches, the location of the wrecks – and their loot – has never been discovered.

Led by General George Monck, a skilled and experienced soldier, a division of Cromwell's army invaded Scotland, destroying all who stood in their path. He arrived at Dundee in August 1651, with an army of around 7,000 and supporting artillery. Dundee at the time was a walled city, and it seems that despite the reputation of the army they faced, this gave those inside the walls some sense of security. Cromwell's forces waited outside the city for a few days, observing and spying on what was happening. It is said they noticed there was a lot of alcohol consumption among the town's militia, with them reported to be often drunk by lunchtime.

No doubt seeing little threat from the forces within, on 1 September General Monck gave Governor Lumsden of Dundee the opportunity to surrender. Beyond all expectations, he refused. It is thought this was due to the influence on the wealthy merchants who had sought refuge within the city, although it is difficult to see what they hoped to achieve by this defiance against such a powerful fighting force. Monck wasted no time and launched an assault on the city. After three hours of cannon fire, the walls of Dundee had been smashed and the Cromwellian forces were ordered to move in. Perhaps in retaliation for their refusal to surrender, Monck is reported to have told his soldiers that they would loot and pillage the town without licence – in other words, they could do as they pleased. The assault on the city took just thirty minutes, with all but the Old Steeple Church being taken by the invading troops. Governor Lumsden had retreated to the church with the remains of his militia forces, and from here he made a last stand. What was happening elsewhere in the town was unlike

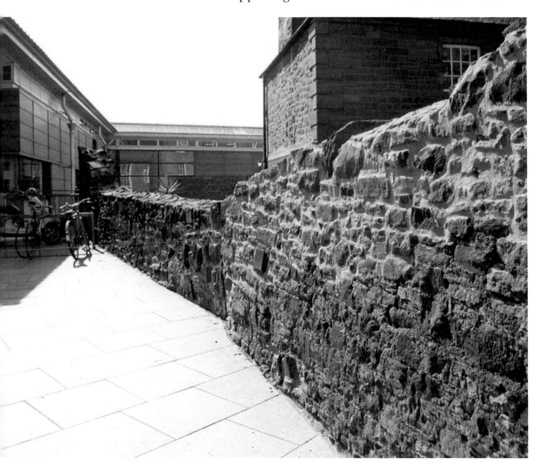

The remains of the old city walls. (Courtesy of Douglas Nelson under Creative Commons 2.0)

The Old Steeple, where Governor Lumsden held out against Cromwell's forces.

anything ever seen before or since in Scottish history – homes were being forcibly entered and the townsfolk raped, robbed and killed. It is commonly said that the massacre only stopped when Monck himself entered the town and upon seeing a screaming child trying to cuddle his murdered mother, he ordered his men to stop. Other reports state that the barbarity went on for a full three days before Monck witnessed the mother and child and, realising he had lost control of his men, he swiftly brought them back into order. Lumsden and his men were again offered surrender, and they agreed on the basis of honourable terms. Unfortunately for Lumsden, the detail of the terms had not been agreed, and when they left the church they were slaughtered. Lumsden's head was removed and placed high on a spike for all to see the consequences of opposing General Monck and his army.

How many people were slain that day will never be known. It is estimated that up to 2,000 men, women and children were killed; most of the town was also destroyed and around sixty ships from the town's fleet were seized to transport the rich pickings. General Monck's forces suffered a loss of just twenty men, with around twenty more being injured. One of Monck's officers reputedly said afterwards that the ferocity of the attack had been brought about by the obstinate attitude of the Dundee people in their belief that they could withstand and attack; however, in fairness, it was not the townsfolk who had this attitude, that lay with the authorities. Dundee, as it always has, rebuilt and grew once again, yet it is still said today that during any building work in the old town centre, it is highly likely you will find the bones of those slaughtered on that day in 1651.

5. The Dundee Witch Trials

In order to appreciate the period of the witch trials in Scotland, which seem like utter madness to us today, it is important to set out the position of the country at the time and how seriously the perceived threat of witchcraft was right up to the very top of society.

The belief in dark magic and that some possessed supernatural powers had existed for some time, and the Witchcraft Act of 1563 was introduced by Mary, Queen of Scots. The Witchcraft Act can now be seen as nothing but an attempt to retain maximum control for the authorities. Some old Celtic traditions remained in the country, with 'wise women' preparing herbal cures for various ailments, something that was frowned upon by the Church as they wanted people to believe only God had the power of life or death. Witch watchers were placed in local communities, tasked to observe how people interacted with each other looking for any signs of reverting to the old traditions, or for failing to attend church at allotted times. This struck fear and obedience into the majority of the citizens, forcing the wise women to practice their trade out of sight, often in remote locations or under darkness, which only added to the evidence against them if caught. The Protestant Reformation brought changes to society, and when it became law, women found themselves with some new rights. Again, the threat of being accused of witchcraft was used to discourage the women from taking up these rights, as anyone seen to be acting out with the perceived ideas of how a woman should act, would draw attention to themselves.

Natural incidents such as crops failing, storms, floods, illnesses and deaths were blamed on witchcraft. A natural fossil known as a gryphaea was a common find on the beaches of Scotland, formed from an extinct species of oyster, yet as these look very much like a claw they became known as Devil's Toe Nails. Finding one on the beach was seen as proof that the Devil was in the area, casting his influence on the weak minded and making them his witches. People could even use witchcraft to get rid of people they did not like, by making simple accusations such as saying they appeared in their dream and threatened to kill them. The ordinary townsfolk were genuinely terrified, as the slightest mistake or fall out could result in them being thrown in jail as a witch.

The events surrounding the marriage of James VI of Scotland (later also James I of England) to Anne of Denmark would signify the start of one of the most brutal

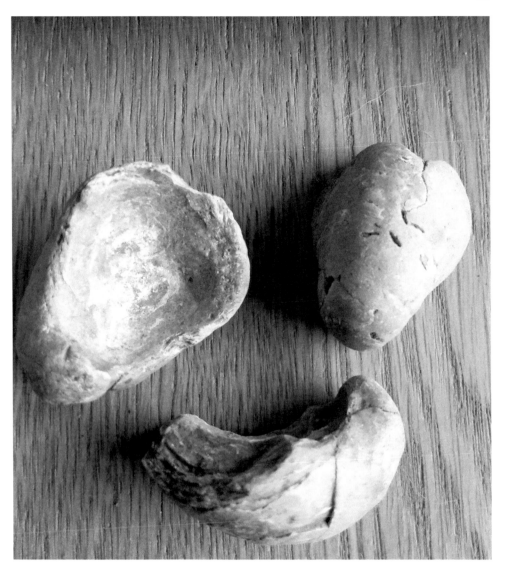

The natural fossil known as a gryphaea that was thought to be the claws of the Devil and proof that evil was in the area.

periods of Scottish history. King James and Queen Anne were initially married at a proxy wedding in Copenhagen in 1589, a strange process given that neither party were actually present. After the ceremony, a fleet carrying Queen Anne set sail for Scotland, yet fierce storms forced the ships to seek shelter in Norway. Anxious to be with his new queen, when word reached King James he quickly put together an entourage of around 300 trusted advisors and assistants and set sail from Leith to Norway, where in November 1589 the couple formally married

in person at the Bishop's Palace in Oslo. After the wedding they travelled back to Anne's native country of Denmark, a country which at that time had deep beliefs in witchcraft. As a keen theologist, King James saw witchcraft as an extension to theology and was keen to learn as much as he could during his stay. Having learned about the trials that had taken place, he became fascinated by the whole subject and was keen to continue to learn.

In May 1590, the couple set sail to return to Scotland and, just as Queen Anne's initial voyage had been hampered by bad weather, great storms that are said to have risen out of nowhere once again forced the ships back. Eventually they safely arrived and, no doubt keen to try to explain the failings, the Danish authorities sought to find the reason for the problems encountered. It is likely that the knowledge of the king's interest in witchcraft influenced what happened next, and a Danish minister was charged with deliberately under-stocking the ships for the return voyage, an act that he knew would make them unstable in storms and potentially have sunk them had they not sought shelter. The minister in turn blamed a local woman of witchcraft, claiming she had sent her imps to replace the barrels laden with supplies on the ships with empty barrels, which caused the instability. The accused was brought to trial and confessed to all of the charges against her, and willingly gave the names of other women she stated were working with her. We now know that this sort of confession was brought about through fear of torture, or actual torture, yet at the time would have seemed clear evidence that witchcraft was real. Among the other women charged was Anna Koldings, known locally as the Mother of the Devil, indicating she was unpopular and even feared. The witch trials offered an ideal opportunity for officials to rid local communities of individuals who did not fit in or who caused trouble locally, and so it is not surprising that someone with a nickname like this would find themselves standing trial. Those named by Anna were also arrested, charged and under torture confessed to have cast spells to try to sink Queen Anne's boat on her first attempt to sail to Scotland, and Anna and around twelve other women were burned at the stake for their crimes.

No doubt keen to clear themselves of any blame in the matter, word soon reached King James that the Danish officials had investigated the difficulties he had encountered, and dealt with those responsible. The curious king went on to start his own enquiries to establish whether any witches in Scotland had also been acting against him, and the first major witchcraft trial in Scotland was launched. Known as the North Berwick Witch Trials, the case would last two years and see around seventy men and women accused of witchcraft. Several of the court hearings and torture sessions were overseen by the king himself, adding authenticity to the risks of witchcraft. Included with those accused was Francis Stewart, 5th Earl of Bothwell and Lord High Admiral of Scotland, who

was accused of using sorcery to try to kill the king. With trusted allies of the king being accused, and the king himself overseeing large parts of the trial before writing his own book on the subject – *Daemonologie* (published in 1597) – it is easy to understand that to the ordinary citizen, witchcraft would be real.

To be accused of witchcraft in these times would result in treatment beyond comprehension today. Such was the fear, simple hearsay or an unconsidered comment was enough to bring a charge. And a charge was an almost certain death sentence. Having had the accusations put to them, no matter how unbelievable, the accused would have been afforded the opportunity to confess. Knowing the consequences of a failing to confess was enough to make many admit guilt. A guilty confession would, however, result in being burned at the stake and so knowing the consequences of an admission equally resulted in many pleading not guilty. Denying the charges was not sufficient for the authorities to consider that perhaps the accused was actually innocent. It was seen simply as a sign that the Devil was still controlling them, and so the confession would have to be forced to break the Devil's bond or to provide other evidence. Unless the accused came from a wealthy and influential family, there was no hope of help due to the following wording from the 1563 Witchcraft Act, which can be found in multiple sources:

> Nor that na persoun seik ony help, response or cosultatioun at ony sic usaris or abusaris foirsaidis of Witchcraftis, Sorsareis or Necromancie, under the pane of deid, alsweill to be execute aganis the usar, abusar, as the seikar of the response or consultatioun.

What the above essentially meant was that anyone found to assist, consult with or aid an accused witch would themselves be considered a witch and be executed as such. Loved ones of those accused had no way to intervene, other than to pray.

The most common torture used for those who refused to make a free confession was sleep deprivation. A rope would often be tied around the head of the accused, painfully tightly, and they would then be walked like a dog on a lead round the cell by guards working in shifts to ensure there was no let up. If they were permitted periods of rest between the walking, they would be tied to rings on the wall in uncomfortable positions, or devices such as the witch's fork (a metal bar with prongs at either end that fitted between the chest and below the chin to force you to hold your head back) would be used. This meant that while you could physically rest from the walking you could not sleep to mentally rest. Other devices to crush digits and limbs, such as the thumb screws (commonly known as the pilliwinks) or the booties to crush lower legs and ankles were common.

Bizarrely, the witch trials created employment for those who were happy to inflict any type of pain on people for money. The role of the witch pricker was both lucrative and in demand. The pricker would be called in find a Devil's mark. This could be a mole or birthmark and was considered evidence that the Devil had removed the accused's baptism and replaced it with his own. These marks were said to be impervious to pain, and so the pricker would push a long, thick purpose-made pin into them to see if there was any reaction. With most people having multiple potential marks, the pricker was in no rush and could prolong

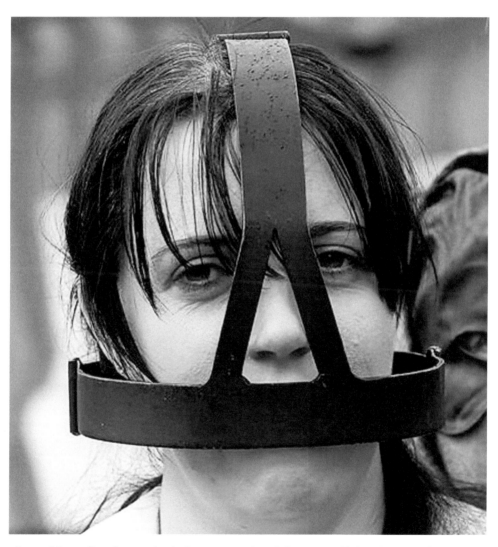

The Scolds Bridle. This method of torture enclosed the accused's head in a steel cage with a strip of metal, often with a spike attached, which would be inserted into the mouth to prevent the wearer from talking. (Courtesy of History and Horror Tours, Perth)

the agony of the pricking process. They were, after all, mostly being paid by the hour, and it was the accused's family who had to pay the bill! And the cost to the family extended right down to the materials used for the inevitable burning. An invoice from a case held in Kirkcaldy is available in multiple publications, as follows:

Expense incurred for the Judge: 6s
Payment to the executioner for his pains: £8, 14s
Executioner's expenses: 16s, 4d
Hemp coats: £3 10s
Making of the above: 8s
Hangman's Rope: 6s
Tar Barrel: 14s
10 loads of coal: £3, 6s and 8d.

The records relating to the witch trials are sadly scant. Whether this is due to deliberate acts to conceal these terrible times or simply a case that these unfortunate men and women were deemed not important enough to have their details noted will never be known. I suspect it is a mix of both, as some of the records we do have available make reference to the number of people executed, but doesn't give details of what specifically they were accused of, or even their names. There is clear evidence that Dundee, as almost every settlement did, had its fair share of cases of witches.

Studying old maps of the city reveals that to the north-west of the town centre, just outside the then town boundary at the West Port, a road used to bear the name 'Witches Knowe'. This would be in the Hawkhill area of the city as it is today. Many towns and cities had a place called Witches Knowe; they were raised pieces of land where the executions took place. These always tended to be outside the town boundary as the belief was that the vengeful spirit of the witch could not enter the town if they were executed and their remains left outside the walls. A small loch was also in this area that was possibly used for 'witch dooking', the process where the accused would be bound and thrown into the water. As water was pure they were deemed innocent if they drowned, as the water had accepted them. However, if they floated the water was seen to be rejecting them as they were not pure, and so they would be taken to the nearby hillock to be burned at the stake. As mentioned before, to be accused was really a hopeless situation. In Dundee, the mound on which the witches were executed is believed to be around Guthrie Street today.

Despite the clear evidence, the records of witch trials in Dundee are virtually non-existent. Some argue that, despite the named streets etc., this shows there

were no cases of witchcraft in Dundee; however, searches through various historical archives start to piece together a picture of the actual situation. In the book *Annals of an Angus Parish*, reference is made that on 27 April 1669, action was ordered by the Presbytery of Dundee against all those found guilty of witchcraft. It is noted that the magistrates of Dundee were to use all diligence in the trials, and as a result all those suspected were banished from the city. Effectively, it seems that the authorities of Dundee moved anyone with even a suspicion of involvement of witchcraft to another area to become another town authorities' problem.

It is possible to piece together some early accounts of witches in Dundee. In the 1845 book *The History of Dundee: From the Earliest to the Present Time* reference is made to notes being found in a diary stating that the Lord Regentis (the Earl of Moray, acting for James VI), while returning from a trip to the north of Scotland, stopped in Dundee and had a company of witches burned at the stake. Reference to the term 'company of witches' tells us that there were more than one accused.

There are also some records of more minor cases around Dundee. On 2 May 1652, Mrs Robertson was charged with charming her child. She was accused of taking the infant to Kirkton Well where she bathed its eyes with water from it while uttering a charm to remove illness from the eyes. Charming was generally classed as a much lower form of witchcraft and so did not have so harsh penalties. No action was taken until 22 May, when both Mrs Robertson and a lady named Janet Fyffe, who it was alleged had taught her how to charm, were sentenced to sit dressed in nothing but a woven sack on the stool of repentance until such time as it was considered they showed sufficient regret and sorrow for their crimes. Stools of repentance were just that: a place to sit to contemplate what you had done. It may not sound a particularly bad punishment, and in these days it certainly was mild. The stool would, however, have been in full view of everyone in the community, and in these suspicious times anyone being sentenced to sit there for such crimes, would be likely to be shunned for the rest of their lives and so the punishment had long lasting consequences.

The women would also be forced to confess in public to their crime, just to avoid any doubt with the local townsfolks. Janet Fyffe did so in the church on 18 July 1652, but Mrs Robertson never did repent, as she died not long after her sentencing. It would be up to the reader to consider whether there may be something untoward in the passing of this young woman charged with lower levels of witchcraft.

The case of Grisselll Jaffray in Dundee is probably the best known – not due to any detailed records, but thanks to small pieces of information being available to allow her story to be built. Not a lot is known about the lead-up to her trial

as the records were mysteriously destroyed. When saying 'mysteriously' I would suggest that it was a deliberate act, particularly as many seemingly sought to have her story put down to nothing but folklore. Had it not been for a fortunate discovery in 1815, when an extract from the town council's minutes was found concerning the case, it is likely that it would be considered just that. Records relating to her husband, Robert Butchart, also help to unravel some of her tale.

Butchart was born in the early 1590s and was a member of an important and influential family of the time, who had been bakers in Dundee for generations. In 1615, he was made burgess and there is some indication he went on to become the first brewer in the town. It is not known when he wed Grissell, who was believed to come from a wealthy merchant family from Aberdeen, although documents do show they lived in a house on Calendar Close, a small court on the Overgate, since lost in the numerous redevelopments of the city and built upon by the current Overgate Centre.

With no records on the reasons for her being suspected or practising the dark arts, it can only be theorised on why such an accusation was brought. With her background, she is likely to have been a confident woman, probably not scared to speak her mind, all traits sufficient for suspicion. Even sharing her knowledge to help others less well educated could be sufficient for her to fall into the category of being a 'wise woman'. Add the fact she was not from the town, probably spoke with an Aberdonian accent, and the reasons add up. There is also a possibility that her family were Quakers, a religious movement set up in 1650 that challenged the ideology of the authorities of the time and was perceived by them as dangerous. The Quakers were persecuted for their beliefs, and if Grisselll had made any move to try to promote the movement in Dundee, it is likely steps would be taken to crush this, which is possibly why she faced the harshest penalty, despite the ruling in 1650 to banish those accused of witchcraft.

DID YOU KNOW?
A large block of stone with the word 'Dundee' crudely written once stood close to the site of Grissell Jaffray's house. It was believed the stone marked the old western limit of the city, on what was the principle entrance route and would have been the point from which distances were measured. Known as the Dundee Stone, research was carried out and references of it dating back to 1565 were found. Bizarrely, rather than being preserved, the stone was buried under the Overgate during redevelopment work in 1812.

Grissell was charged on 11 November 1669, although she is likely to have been held as a prisoner in the Dundee tollbooth before that. Again, no details of her trial exist, and it is only through gathering snippets of references from other publications that it is possible to say with some certainty that she did undergo a trial. Heading the trial were John Kinloch, Dean of Guild, and John Tarbert, Provost of Dundee, and details of the evidence that was presented to them is unknown, she was convicted of witchcraft, as there is reference during her being found guilty due to the mark. This would be reference to the Devil's mark, mentioned earlier in the details of the ordeals those accused of witchcraft faced. What is not known is whether this mark was simply found on her body, or whether Grissell underwent the agony of the witch pricker. She was executed on 23 November 1669 – twelve days after being accused, and so it is likely she underwent some form of torture to confess. She was burned at the stake in the Seagate area of Dundee. Later records show that her husband made an application to be admitted to 'The Hospital', an early form of poorhouse. Whether he lost his wealth through having to pay for Grissell's trial and execution, being shunned afterwards or for some other reason is unknown, as seems to be the norm for this case. It is, however, a sad end to the tale of two once prominent members of Dundee's society.

While Grissell Jaffray has gone down in history as the last witch burned in Dundee, some short references indicate this may not have been the case. A passage in the minutes book of the time reputedly say that Grissell gave the names of others who had acted with her at her execution. This is the final record relating to her death, and the names of the women she gave and the consequences of this are not recorded. It would, however, be highly unusual for it not to have been followed up on, and in February 1670, a 'prover', or witch finder, was employed in Dundee.

The story of Grissell Jaffray does not end with her death, which is probably why her tale has survived. It is said that she had a son who, following in both his mother and father's background, had become a successful merchant. He was returning to Dundee on 23 November 1669 when he was alerted to the smoke coming from the Seagate. When he landed, he enquired what was on fire, and was told it was his mother! Upon hearing of her fate, he returned to his ship and set sail – cargo still on board – never to return to the city again. This story was immortalised in the poem 'The Witch-Wife's Son'.

By the time the Witchcraft Act was repealed in 1736, it is estimated around 2,000 people had been put to death for this crime. But that was not the end of Dundee's connection with witchcraft. In the *Scots Magazine* in early 1818 a letter was published telling the story of a lady named Janet Kindly, better known as Hurkle Jean – with 'Hurkle' meaning she was likely hunchbacked. The description given of Janet was that she was poor, old and deformed, and possessed an evil

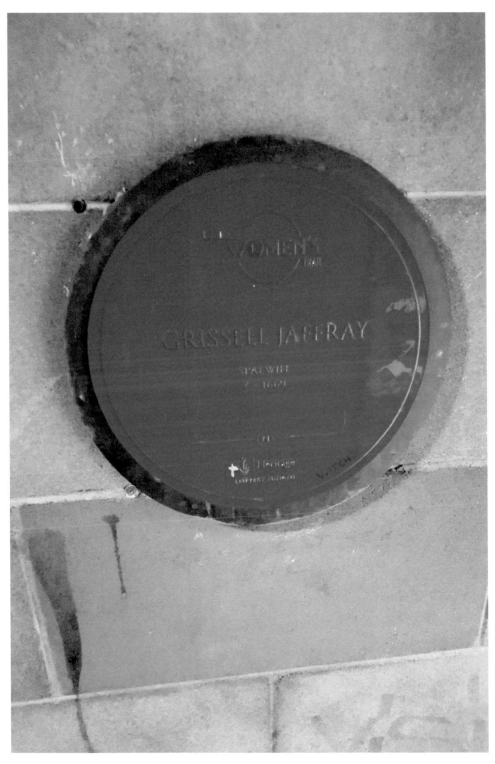

The memorial plaque to Grissell Jaffray.

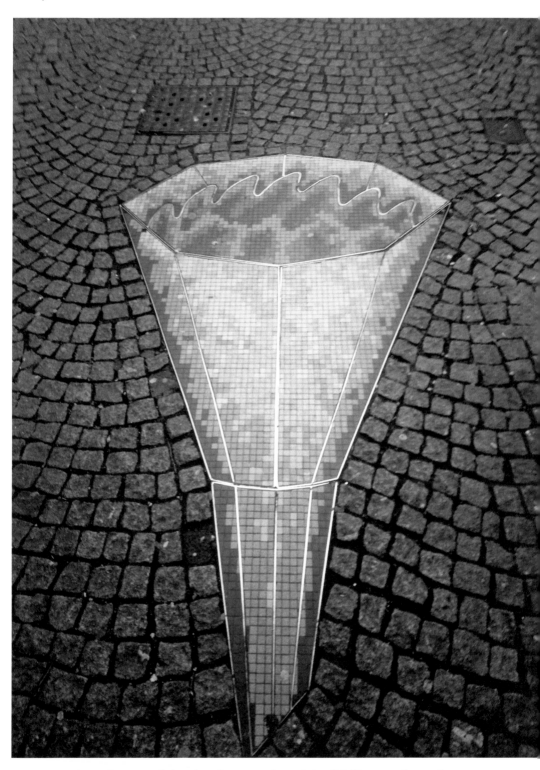

A mosaic on the ground showing the area where Grissell Jaffray was burned.

The Witch Stone in the Howff Kirkyard.

Offerings are still left today to the accused witches at the Witch Stone.

eye that the locals dreaded. She was often blamed for illnesses both of children and livestock, and if she crossed the path of a fisherman on his way to the boat it was considered the trip would be worthless and often abandoned. With the Witchcraft Act being repealed, nothing could be done about Janet; however, after a single boat in the fishing fleet had not landed fish for months the fishermen had their own remedy, following their own traditions. It was said the incident took place six years prior to the letter being published – so around 1812. Fearing the boat had been cursed in some way by Janet, an exorcism was to be performed to rid the boat of her spirit. A straw effigy of Janet was placed in the boat above a small cavity known as the Tap-Hole. This had been filled with what is described as a particular kind of water, prior to the effigy being placed over it. The boat was then towed out to sea before sunrise, and the effigy burned between the sun and the sky, meaning after daylight broke, but before the sun rose from the horizon. As the straw figure burned, the master of the boat cried out 'avoid ye Satan' and, after the sun rose, the boat was returned to dock. From that day on it is said the boat was once again successful in landing fish.

Dundee's final connection with witchcraft was as recent as the Second World War, when a lady named Helen Duncan was arrested. Born in Callander, Perthshire, in 1897, Helen worked in the Dundee Royal Infirmary since she left school. She met and married a man named Henry Duncan, who was a war veteran and cabinetmaker. From a young age, Helen had caused alarm among her peers as she would make prophecies of doom and channel spirits. Her husband did not seem to have any objection to this, and in 1926 she began offering séances to those who wished to contact the dead. Her reputation grew, partly due to the ectoplasm that seemingly poured from her mouth while performing the séance. She was described as a materialising medium, and it was from this ectoplasm that she could ask spirits to form and communicate with her. As Helen's popularity grew, she left Dundee and moved around the country, finally settling in Portsmouth. It was here that, in 1944, she attracted the attention of the officials when she began to channel the dead sailors from the HMS *Barham*. What concerned the authorities was that, although the ship had indeed been sunk several months earlier with the loss of 861 lives, the War Office had not officially announced the sinking and it was being kept quiet as they did not want a drop in morale just weeks before the planned D-Day landings. It is said that the officials were concerned about what other information she may have known and may release, stating she obtained it from spirits. She was arrested, yet there was a difficulty on what to actually charge her with as she had not broken any laws. In a desperate act, the officials looked to the Witchcraft Act of 1735. This had been brought in to create UK-wide legislation after the joining of the nations and to replace the individual countries earlier acts. The penalty for witchcraft was imprisonment, but with no real belief

in witchcraft it was rarely used other than to quell behaviour that the authorities did not approve of, which was the case with Helen. She was held in prison for nine months and released on 22 November 1944, after which she pledged never to hold a séance again. However, she did return and in November 1956 the police again raided her séance. Just five months later, having been hounded by the authorities and a small minority of the public, Scotland's last witch died.

DID YOU KNOW?
A tradition in Dundee says that when the Jaffe brothers constructed their Jute Mill, excavations revealed a large mound of heavily charred wooden ashes. Although there is no evidence, the tale persists that this was the remains of the fire on which Grissell Jaffray was put to death.

6. The Industrial Growth of Dundee

During the eighteenth century, Dundee grew into an industrial powerhouse. By this time, the city had already established itself as a trading port, and so it is not surprising that this period of rapid growth centred around the docks.

Ships were getting larger and the mouth of the Tay Estuary offered one of the few places along the east coast of Scotland that was wide enough and deep enough for the larger ships to seek shelter. The docks were adapted accordingly and offered safe mooring as well as ship repairs and maintenance. Around the 1720s, shipbuilders started to establish themselves around the dock.

Whaling, an industry much frowned upon today for its barbarity, grew from around the 1750s in Dundee. Whaling was already a big industry around large parts of the world by that time, with ships seeking shelter and repairs in Dundee on the journey to, and especially back from, the Nordic region and so it

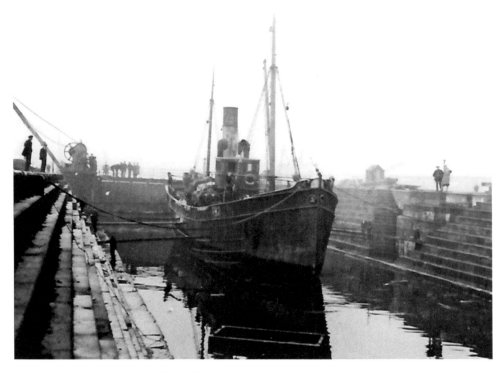

Early photo showing one of the ships in Dundee Docks – age unknown.

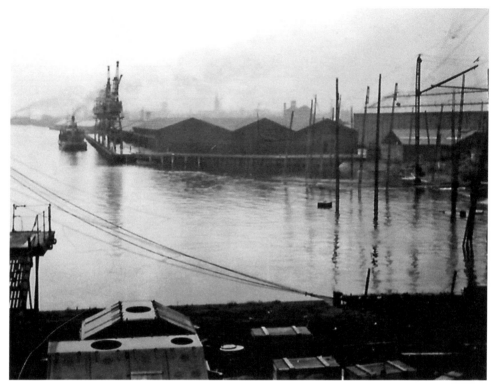

Early photo showing Dundee Dockyard – age unknown.

was inevitable that Dundee would eventually enter into the industry. The first whaling boat, aptly named *Dundee*, set sail from Dundee Docks in 1753. Before long the shipbuilders were able to use the experience gained through the repair work to design and build ships better suited to deal with the conditions they would face in the Arctic Ocean. Whaling would bring great wealth to Dundee, not only through the industry but by products, such as the whale oil used for street lighting and by the wealthy to provide oil heating in their houses.

One of Dundee's best known industries, and one of the three 'Js' that the city is famous for, is widely said to have originated from a ship seeking shelter in the bay. Janet and John Keiller ran a small but successful shop in the city selling cakes, sweets and fresh fruit, when a Spanish ship entered the Tay Estuary to shelter from a storm. On board was a cargo of Seville oranges that were already starting to go off. Knowing that there would be a delay in Dundee, and desperate not to lose the lot, the captain of the ship offered the oranges for sale, and they were bought by John Keiller. The captain was no doubt happy to offload what was fast becoming a worthless consignment, yet John Keiller knew he had got a bargain. Unfortunately for Janet, it fell on her shoulders to make something

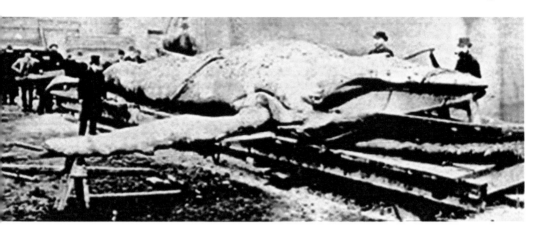

The Dundee 'Monster'.

useful out of the already bitter oranges. She dug through her recipes for fruit preserves and, having tried a few, settled on one that included the peel, creating the first marmalade to contain the rind of the fruit, which would go on to be known as Chip Marmalade.

Such was the success of this mix that by 1797 Janet and her son, James had set up a fruit preserve company named James Keiller, which later changed to James Keiller & Sons in 1804. Janet remained active within the company until her death in 1813, constantly adapting and creating new recipes. By 1845, the company had moved to new premises in Castle Street and their original premises at the Seagate were converted to a production factory with steam-powered machinery, creating the first commercially produced marmalade. By 1869, John Keiller & Sons was the largest confectioner in the country, employing more than 300 people.

During this time the whaling industry had begun to decline worldwide. American ships brought increased competition and overfishing, and coal gas was replacing whale oil for lighting. While whaling ports across the country were closing, Dundee was doing the opposite and expanding. The reason for this was jute, one of the town's 'Js'.

Dundee had an established linen industry and was importing and exporting products across Europe and beyond, with sail linen being one of the biggest markets. In 1820, a ship arrived with twenty bales of jute at Dundee, which marked the start of one of the most defining periods in Dundee history. As a natural fibre jute is very strong and versatile; however, when shipped in tight bales, it became as hard as wood, which is what had happened to the bales dropped at Dundee. In order to use the jute, the fibres needed to first of all be separated into bundles and then softened by spraying them with a mixture of oil and water, with whale oil being ideal for the process. In no time the linen mills were being converted to

The former Keiller store and bakery at Castle Street, occupied by Keiller from 1845.

The memorial plaque to Janet Keiller.

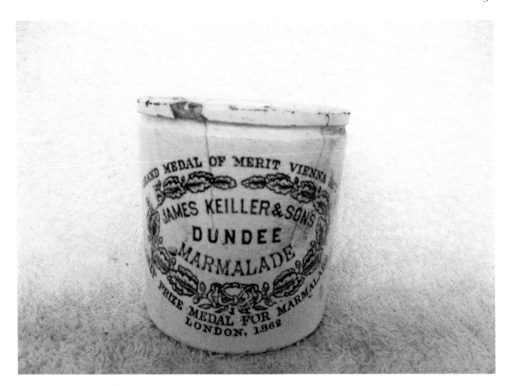

Vintage jar of Keiller's famous marmalade.

Keiller's expansion into confectionary included a number of special presentation boxes.

The former Keiller factory at Mains Loan.

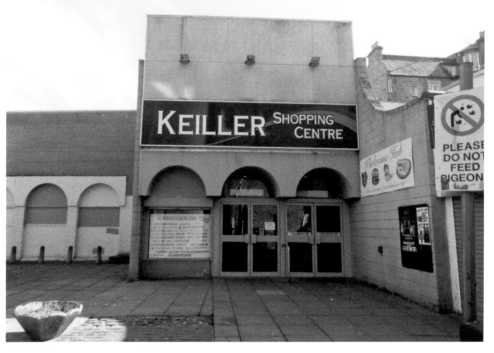

The Keiller name lives on in Dundee with the Keiller Shopping Centre.

work the jute, and the demand for whale oil grew. The shipping industry also saw a substantial boost from the jute production, with bigger and faster ships being constructed to collect the raw jute from India and bring it back to Dundee.

DID YOU KNOW?

In December 1883 the Dundee whalers did not need to make the dangerous journey to their fishing waters because a large humpback whale swam into the River Tay. The ships were quickly sent out in pursuit and although the whale was harpooned, it escaped. However, the injury was fatal, and a week later the body was found and towed to Stonehaven Harbour, where it was bought by Dundee whale merchant John Woods, who brought it back to Dundee and put on display as 'The Tay Monster'. After decay set in, an autopsy was carried out and the whale was stuffed and put back on display. The skeleton is held by the McManus Museum in Dundee.

Between 1820 and 1877 new docks were constructed. The introduction of the railway to the docks in 1838 significantly improved the speed at which both produce and materials could be taken into and away from the port and opened up the Dundee industry further across the country. By 1857 the jute industry was going through around 2,000 tons of whale oil and a new fleet of whaling ships was built to meet the demand. The ship *Tay* was the first whaling ship to be powered by steam engines, making the journey quicker and enabling it to better deal with the frozen waters. In 1888, the clipper ship *The Lochee* set a new record by sailing from Calcutta to Dundee in 113 days. Around the new docks, new whale oil processing factories and tanneries were also established.

The versatility of jute allowed it to be used in numerous products, including boot linings, sacks, ropes tents and tarpaulins. As a much stronger material than linen, it was also better suited for ship sails, especially for the Dundee whaling ships. By the 1830s the demand for jute began to exceed the demand for linen, and the mills that still produced both converted to purely jute production. New mills were also established with steam-powered machinery, all of which were lubricated by the whale oil, and the city earned the nickname 'Juteopolis'. The boom years for jute production were between 1860 and 1870, when 100 mills provided employment for around 50,000 people, which represented half of the working population in Dundee. To cope with this, in 1867 Dundee had twelve steam-powered whaling ships among its fleet and Dundee was the only whaling port surviving in the UK at that time.

DID YOU KNOW?
A humorous version of the tale of the origin of Keiller Marmalade tells that it was Janet Keiller's son, James, who found the oranges washed up on the beach, having been dumped overboard. He took them to his mother, who came up with her recipe, and promptly shouted to her son to return to the beach and get 'mair, ma lad', so she could make larger batches. It was this cry that was said to be the origin of the name 'Marmalade'.

Yet while the merchants of the city became richer, the employees were driven into extreme poverty. Influxes of people desperate for work arrived, driving the wages down, while at the same time the ever-growing demand for the limited residential accommodation around the mills grew, driving the prices up. Strathearn Road, the favoured site for the Jute Mill owners to have their homes built, became known as Millionaires Mile, and was considered to be the richest mile of real estate in the country. Meanwhile the workers faced severe overcrowding and suffered from poor sanitation and the effects of the machinery they were using causing deafness and respiratory problems. The whaling industry that supported the jute mills also brought great risks. Although it is estimated to have brought employment for around 4,000 people, many suffered the ill effects of the weather conditions, returning with ailments such as frostbite. The wrecks of around forty whaling ships from Dundee are said to lie beneath the ice of the Arctic whaling region. By 1863, the average life expectancy for a man in Dundee was just thirty-three years.

By the start of the twentieth century, everything started to fall into decline. The demand for jute dropped due to the production of new materials and India producing jute products itself. Mineral oil was also introduced, which was substantially cheaper to produce than whale oil. This marked the beginning of the end for both Dundee's jute and whaling industry. The information gathered by the whalers was, however, still able to be put to good use. The captains of the whaling fleets had been required to navigate the coastline of the Arctic, producing maps showing the landscape and natural harbours. The waters of the Antarctica, however, remained uncharted and the lands unmapped. When the Royal Geographical Society planned the British National Antarctic Expedition in 1900, it was the Dundee shipbuilders they looked to for the construction of a ship able to cope with the conditions and crushing ice. The Dundee Shipbuilders Company were commissioned, and the Royal Research Ship Discovery was the result. The ship is based on the design of the whaling ships, yet due to the requirement for exclusion zones of 30 feet for any metal from the ships' sensitive magnetic observatory, some adaptations had to be made. Although designed as a sailing ship, coal engines were added for when the

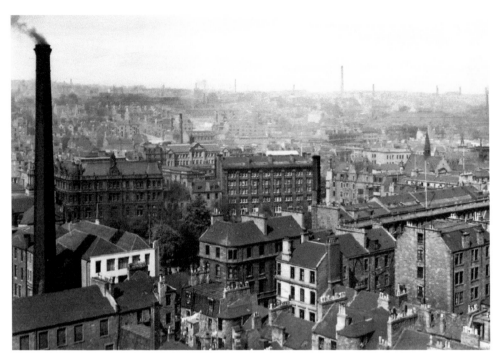

Photo taken overlooking Dundee showing the many chimneys of the multiple jute mills.

Further photograph showing the scale of the chimneys from the jute factories.

Even into the early part of the twentieth century living conditions in the main residential areas in Dundee were poor.

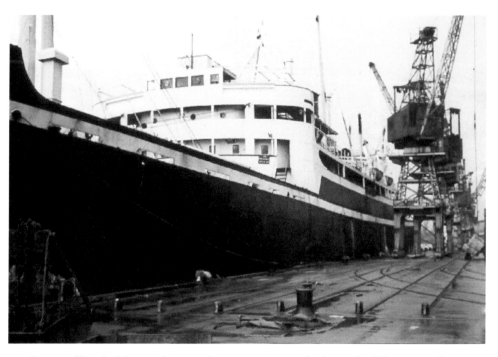

Jute being offloaded from a boat in the 1960s – towards the end of the jute industry in Dundee. (Courtesy of Val Vannet under Creative Commons 2.0)

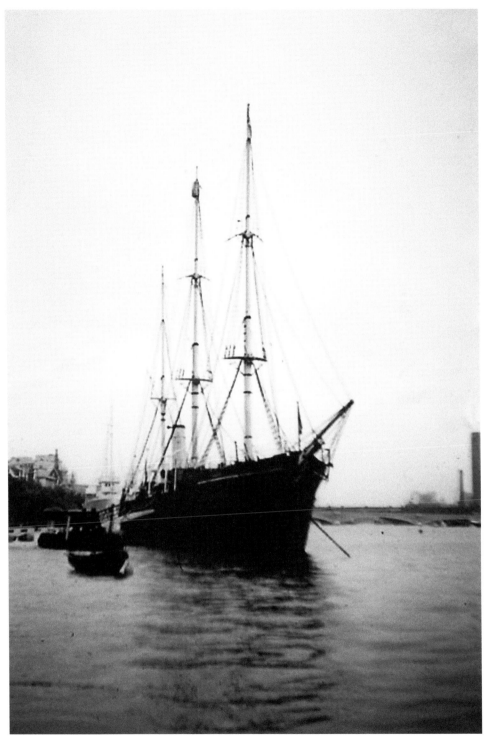

The RSS *Discovery* in the River Thames in 1968. (Courtesy of Richard Hoare under Creative Commons 2.0)

conditions were such that sailing was impossible or additional power was needed. The crow's nest, which stood some 110 feet above the deck, also had to be adapted, with observation holes being made in the sides, allowing the unfortunate soul sent up to keep watch the opportunity to do so from within the shelter of the structure itself. The ship set sail from the Tay on 21 March 1901, and initial reports that it was found to be a bad sailor were dismissed as the boat was designed with a shallow hull to cope with the ice fields, rather than the open waters it was being judged in. Once the ship reached the southern hemisphere and encountered the strong winds known as the 'Roaring Forties', the ship proved itself to be more than capable of dealing with the extremes of weather.

DID YOU KNOW?
It was once not uncommon to see Eskimos walking the streets of Dundee. While Dundee whaling ships were trapped in the ice caps, the sailors would often spend time with the Inuit Eskimos. Having established their trust, the whalers were able to learn more about native whaling methods. Eventually, some of the Eskimos would visit Dundee, carried on the whaling ships, to allow them to experience the culture in the city.

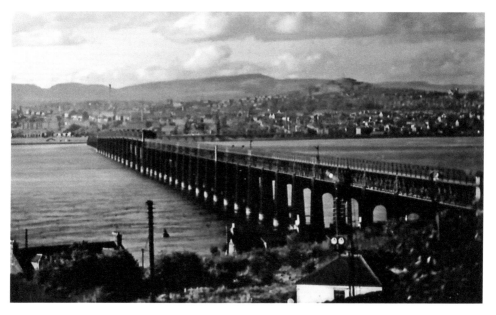

The opening of the Tay Rail Bridge in 1878 vastly improved transportation links for Dundee. After the Tay Bridge Disaster of 1879, the second bridge was opened in 1887.

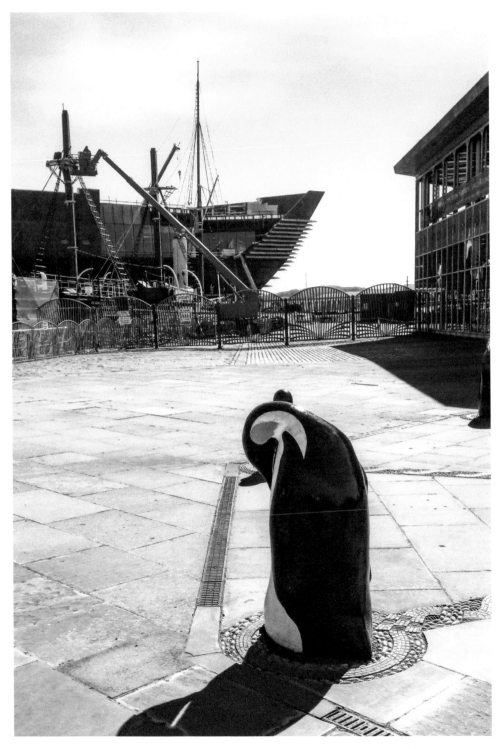

There are several penguins around Dundee, which serve as a reminder of the exploration of the polar caps.

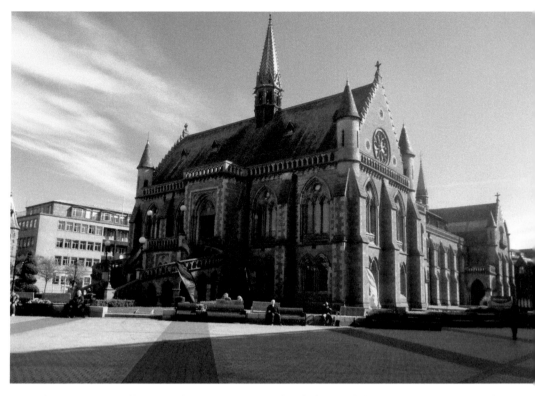

The McManus Galleries and Museum, where the skeleton of the Tay Monster is stored.

7. The City of Women

One defining factor of Dundee, particularly in the way it grew and developed over the industrial period, is the women of the city. While there had been early attempts to crush any desire of women to take up opportunities and rights through the Witchcraft acts discussed earlier, Dundee stood out in the nineteenth century with a complete role reversal.

The jute industry was built largely of the back of the linen industry, which existed in the town. While the men of Dundee would carry out the more physical tasks, it was the women who were nimble fingered enough to work in the linen mills. When the jute industry took off, it was the women once again who were desired to work in the mills. There were several reasons for this, some legitimate, some more questionable. The skilled linen workers were naturally suited for working the jute mills and, with children also working there, it was mainly the daughters who were being taught to work with the mothers, creating the next generation of workforce. While sons would have also carried out the work, men were legally entitled to pay rises that women were not, and so the tendency was to lay off the male workers once they reached an age when they would receive extra wages. The steam-powered looms were not favoured by the male workforce yet they made the work far less physical. As such, they no longer needed the stronger male arms to operate them and the men were willingly replaced with women. The working-class woman was also less likely to have any form of political motivation and simply sought to turn up, do a good day's work and go home, vastly reducing the risk of strike action within the mills. Many of those who moved to Dundee seeking work were moving from places with no employment for anyone, and so it was the women hoping to find employment in the mills who brought their husband and children with them. This provided a plentiful supply of women workers and their children who were also employed with mills, resulting in the setting up of education facilities and allowing child workers time to study.

All in all it was a dire time for the male worker. Women were outnumbering their male counterparts by three to one in the jute mills. As the jute mills accounted for around 50 per cent of the employment available, men started to stay at home to look after the house and children while the women became the main wage earners. Dundee became known as the 'She-town', with the women

The South Mill, Brown Street.

Logie Works (also known as the Coffin Mill due to its unusual shape).

The Lindsay Street Mill.

becoming more like a stereotypical man of the time. Even with the power looms, work at the mills was hard, and the women working there developed a hardened attitude. They were generally quicker to speak their mind than most from other towns, and developed a bit of a reputation for being loud, confident and overdressed. It is also said that the women, as the main wage earner, would be the more frequent visitor to the pubs, often stopping for a few well-earned drinks on their way home and arriving back under the influence of those drinks, much to the annoyance of their husbands! The men earned the nickname the 'kettle bilers', or kettle boilers, meaning they were seen to be passing the time in the house, keeping the kettle boiled for their wives when they returned from work.

But things would change for the wealthy mill owners. As the women workers became more confident and assertive, they became more aware of their rights. Strikes started to break out across the mills, with employees demanding fair pay rises and better working conditions. Many of these strikes were organised by the workers themselves rather than through trade unions, making negotiations more complicated for the owners.

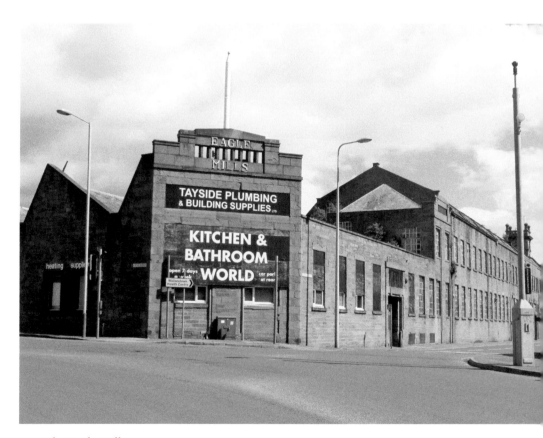

The Eagle Mills.

The Camperdown Works – now converted into flats.

Cox's Stack.

It is perhaps unsurprising that when the suffragette movement started to win the right to vote for women, the cause was strong in Dundee. One of the best-known suffragettes in Dundee is Ethel Moorhead, who took a more militant view of the campaign. Also recognised as the finest female painter in Dundee, Kent-born Ethel moved first to Paris where she trained as an artist, and then to Dundee in 1900. She joined the suffragettes in 1911 and it would be fair to say caused disruption all around. Of all of the outrages at the time that she caused the one she would become best known for was more about who, rather than what. She threw an egg at the local MP, which would not ordinarily be something she would become famous for, but the MP for Dundee at the time not been Winston Churchill, who would later to go on to become the wartime prime minister.

Plaque commemorating Sir Winston Churchill in Dundee.

Dundee is fortunate in that many of its women have been remembered through the website and book, *Dundee Women's Trail*, which documents the achievements of the women of the city. A few examples follow.

The first example is perhaps not an achievement to be proud of, but it is certainly an achievement nonetheless. Margaret Gow, better known as Mag Gow, was a fish seller in the town, but she was better known for her drinking. On 20 May 1870, she made her amazing 200th court appearance, with the judge widely quoted as saying 'Nobody is so inoffensive as Margaret Gow, yet when you get drunk you lose your senses'. She tended to be sentenced for a day or two, normally just long enough to get sober, before she would be released and it would all start again.

Anna Dodge was born into a middle-class family in Dundee in 1871. Her mother was widowed while she was young and the family moved to America to start a new life. Anna grew to be a gifted pianist and may have become a concert pianist had she not damaged her hand in an accident. She became a piano teacher in Detroit, where she was able to earn enough to support both herself and her mother. When she was twenty-five she married a mechanic named Horace Dodge, who went on to set up a garage manufacturing bicycle parts with his brother. This grew to manufacturing car parts, and then cars, ultimately becoming the Dodge Motor Car Company. When Horace died in 1920, Anna inherited his fortune of £24 million, which was put into bonds yielding her £625,000 a year. It may not sound much compared to some of the staggering wealth we see today, but at that time Anna was said to be the richest person in America.

Agnes Husband was one of Dundee's first female councillors and a suffragette. Born on 20 May 1852 in Tayport, Agnes started her working life in Dundee as a dressmaker. When she was in her forties, Agnes became interested and involved in the socialist cause and sought to join the Labour Party. Having initially unsuccessfully tried to join the school board of the town council in 1897, she started to attend numerous meetings, and in 1905 she did successfully secure a place on the board, where she promoted the education of the poor in the city, including providing meals and books.

She later became the president of the Women's Freedom League in Dundee and started working with the suffrage movement in 1909. In recognition of her work on behalf of the poor of the city and for the rights of women, in 1926 she was awarded the Freedom of the City.

Jessie King was a journalist – journalism is another of Dundee's three 'Js'. Born in 1863 in Bankfoot, as a child she was a great reader and was actively encouraged in her studies by her father. She later started working in an office in the village, where opportunities arose for her to develop her writing skills. After winning a number of prizes she was offered a position working at the *Dundee Advertiser*,

before moving to a promoted post with the *Dundee Evening Telegraph*. Thanks to her writing style, which was described as 'graphical' in the way she could bring a story to life by painting a picture for the reader, she became very popular and one of the most famous journalists in Scotland.

DID YOU KNOW?
Dundee can lay claim to a connection to one of the most famous horror stories of all time. Mary Shelley spent time with the Baxter family in Dundee from the age of fourteen, and the city was an inspiration for the setting of her famous novel *Frankenstein*.

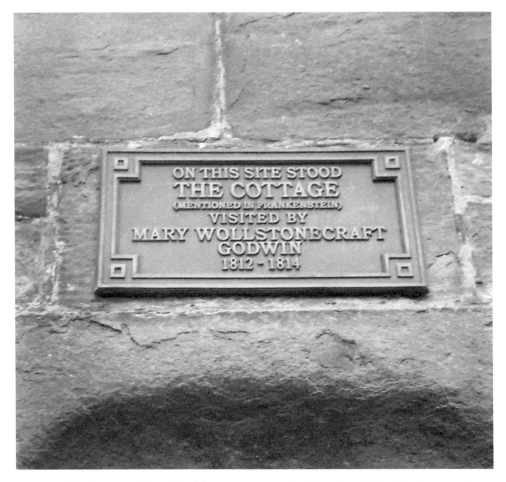

A memorial plaque on the wall of the property on the site where Mary Shelley stayed.

8. The Great Fire of Dundee

In 1906, a rather bizarre incident took place in Dundee that would literally see the streets on fire.

Sat on the corner of Seagate and Trades Lane stood the warehouses for the wholesale whisky merchants James Watson & Co. At the time, the warehouse was the largest such building in the whole of the UK, containing over a million gallons of whisky. On the evening of 19 July, an employee passing the building reported seeing smoke coming from the roof. He immediately raised the alarm but the fire quickly took hold and the vats of whisky soon started to rupture and explode, spreading flaming liquid across the surrounding area as though it was raining fire. As a result, the fire quickly spread to other buildings, including another smaller whisky warehouse in Candle Lane. Firefighters struggled to contain the fire and additional fire engines from as far away as Edinburgh had to be brought in to try to get the inferno under control. By 2 a.m. it was reported that a massive jute warehouse, owned by J. Robertson & Son, was also on fire, as were a number of other smaller buildings. Streams of flaming whisky were also pouring down the streets, creating a never before seen spectacle.

Despite the great risk, the temptation was too much to bear and large crowds gathered to watch the fire, hampering the efforts of the fire service. It was estimated that around 1,000 people lined the streets, watching the burning rivers flow along the road and into the drains, which itself created additional danger. When one large 2,000-gallon tank burst, the explosion smashed all of the windows in the surrounding buildings and blew a firefighter clear across the street. Fortunately, he suffered no significant injuries. The flaming whisky at that point, however, began to pour from the windows and down the side of the building.

The fire then spread to the Scottish Co-operative Wholesale Society warehouse, in which 2,000 sacks of sugar were ignited. It was reported that the fire from the sugar was even more intense than the fire from the whisky, and in just ten minutes the Co-Operative warehouse collapsed due to the intensity of the heat. A factory manufacturing calendars also caught on fire, but swift action by the fire service meant they were able to extinguish the flames before they took hold. The premises caught fire again several times, but each time were successfully put out.

The Watson Bond – now converted into accommodation. (Courtesy of Bill Nicholls under Creative Commons 2.0)

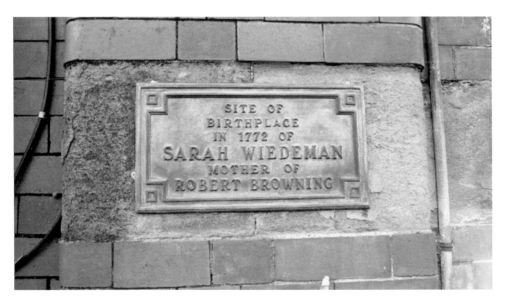

Memorial plaque to Sarah Wiedeman on the Watson Bond Building. (Courtesy of Bill Nicholls under Creative Commons 2.0)

It took until noon the following day before the fire was brought under control, and by that point there were real concerns that the walls of the warehouse would collapse, exploding any surviving tanks of whisky and pouring all of the liquid inside out onto the streets. Having also brought the fire at the jute warehouse under control, when it was safe for the building to be entered and checked it was discovered that another jute warehouse belonging to J. Henderson was also on fire, with an estimated 3.000 bales of jute alight.

It was the worst fire to hit Dundee for over 250 years, with large areas of the Seagate and Candle Lane being destroyed. Once the fires were extinguished and the damage assessed, the papers reported the estimated losses as follows:

Wines and Spirits	£184,000
Co-Operative Society	£ 7,000
John Robertson & Son	£ 70,000
Trade Lanes Calendar Co	£ 5,000
Miscellaneous Property	£ 80,000
Total	£346,000

That is a huge amount of money, estimated to be the equivalent of around £35 million today. The amount of whisky lost is estimated to have been enough to give every adult in Scotland six bottles each.

The losses with the fire did not stop there, however. The insurers, Regent Fire Insurance Company, struggled to meet the claims and was absorbed by the Perth-based insurance giant General Accident.

DID YOU KNOW?
A memorial plaque on the James Watson bonded warehouse commemorates the site as being the birthplace of the writer and poet Robert Browning.

9. Dundee Today

In the first half of the twentieth century, Dundee once again found itself in a position where the industries were in decline. Whaling ships that were going out of service were no longer being replaced, and the whaling industry had ceased trading by 1914. The decline on demand significantly impacted on the shipping industry. The Royal Research Ship *Discovery* had spent a number of years stuck in the ice caps of the Antarctica before being freed by two relief ships in 1904. The trip was however, a success, and Captain Scott returned with the ship to the ice caps in 1910 in his ill-fated expedition. The *Discovery* went on to be used as a training vessel in London.

DID YOU KNOW?
Dundee is still revealing its secrets today. In the year 2000 contractors found some unusual stonework while carrying out work in Exchange Street. Further exploration revealed a series of long forgotten underground vaults. Research revealed that the vaults may date back as far as the 1640s and were used for storage for the docks. They were covered around the 1750s and forgotten about.

By 1920, the jute industry was facing fierce competition from worldwide markets. There was a resurgence in demand during both the First and Second World Wars but it again slumped after 1945, and the last mill – the Taybank Mill – closed in 1989. The jam industry, born from Janet Keiller's original marmalade recipe, did better, employing around 800 people in Dundee in 1914. In 1918, the company was bought by Crosse & Blackwell, which at the time was the largest food production company in the British Empire. The Keiller brand remained, cornering around 20 per cent of the UK market, a production level that made it the largest fruit preserve company in the world, and in 1931 Keiller, by royal appointment, became the official suppliers of marmalade to the king and chocolate to the queen. Well-known brands such as Toblerone were being

produced by Keiller's confectionary division, and by the mid-1940s they operated a number of baker's stores across Dundee. The fierce worldwide market was to once again have an impact, and subsequent company takeovers and mergers saw Keiller's lose the licence to produce Toblerone. In 1980, with the Dundee operation facing closure, a number of attempts were made to save the brand; yet, by 1988 production of the preserves in Dundee had ceased, with the brand name retained only for marmalade for the export market.

DID YOU KNOW?
On 25 August 2018 the local press announced that the foundations for Dundee Castle had been found while renovation work was being carried out on a property in Castle Street. This has long been believed to be the location for the castle, and this discovery confirms that, and will allow further research to be carried out.

Yet again, Dundee showed remarkable resilience and adapted to the changing world, using the skill base it had. Recognising the advances being made in technology, Dundee began to offer incentives for new companies to come to the city, promoting the long background in industrial engineering. One of the first to arrive was the American giant, the National Cash Register, known simply as The Cash by Dundee locals. In 1946, the NCR facilities at Camperdown were opened to produce cash registers, and within twenty years the company had opened a further five factories in Dundee, growing to become the largest single employer by 1960.

The NCR Camperdown site opened in 1946, with production going back to cash registers based on the American methods. Within twenty years the company had a total of six factories in the city, employing around 4,000 people, increasing to 6,000 by the end of the 1960s, making it the largest single employer at that time. By 1970, worldwide competition had significantly reduced the production in Dundee, but once automatic teller machines (ATMs) were introduced, NCR adapted to become the main supplier in the country.

Another American giant, Timex watches, was brought to Dundee, opening a massive 36,000-square-foot factory at Dundee in 1947. The work was highly skilled, requiring excellent hand-eye co-ordination, and the workers from the weaving will had just the skills required. With far better working conditions and pay, the former mill workers flocked to take up employment. The company grew

The Van Leer building at Camperdown, showing the front and side elevations in 1997. (Courtesy of the Scottish Civic Trust)

The front and right elevations of the Van Leer building, 1997. (Courtesy of the Scottish Civic Trust)

All that remains of the Van Leer factory today.

The Dundee Ice Arena stands on the site of the former Van Leer factory.

The current NCR premises on the Kingsway.

to open two further factories in the city. In the 1970s the factory began developing work for Polaroid cameras and in 1981 started to manufacture the famous ZX-81 for Sinclair, the first widely accessible home computer.

A third major American company arrived in the 1970s when Levi Strauss opened a factory in the city manufacturing their famous jeans. Again, Dundee had an ample workforce from the jute industry with nimble fingers who were perfect to fill the factory with workers ready to go. The company soon had to move to a large, 55,000 square foot factory to meet the demand and was employing up to 700 people producing around a million pairs of jeans a year. In what was becoming familiar cycle, competition from across the world and cheaper labour in developing countries eventually took its toll, and in 2002 the factory was closed.

But Dundee was not beaten. The Tay Road Bridge opened in 1966, replacing the passenger ferry and making it significantly easier to access the city. In 1972, the tyre company Michelin opened a factory in Baldovie Road to produce radial tyre, a design that included steel cord to improve the stability of the tyres. Michelin managed to adapt to survive several challenges it has faced, including the 1980s

The Timex factory, now occupied by the JTC Furniture Group.

The entrance to the former Timex factory.

A mosaic marking the spot of the Timex bus stop, where factory workers would be dropped off and collected.

The watch that forms the centrepiece of the bus stop mosaic.

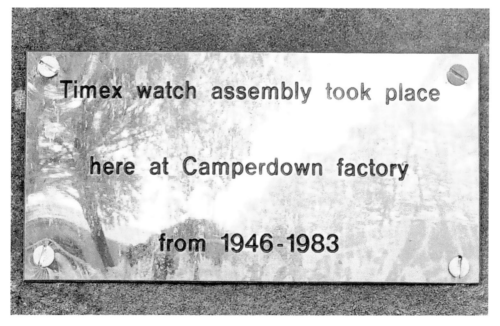

A plaque commemorating the role of Timex.

The Sinclair ZX81, the first home computer easily accessible to many households.

The former Levi Strauss factory.

Construction of the Tay Road Bridge. (Courtesy of Elliott Simpson under Creative Commons 2.0)

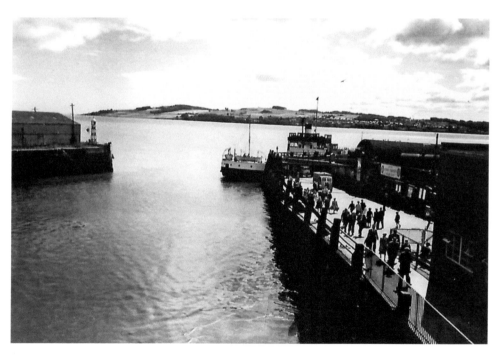

The Tay Ferry.

when car production dipped significantly, reducing the demand for tyres for new cars. The company now employs around 1,000 people in the city, bringing an estimated £45 million to the local economy and producing 7 million tyres a year.

In 1974, Dundee's Ninewells Hospital opened, providing both teaching and medical research facilities, allowing Dundee to build on its medical past to become a leading city in the studies of illnesses and scientific research for medicine. The Technology Park opened in the early 1990s, encouraging more companies to move to the city, including the Perth-based insurance company General Accident, who adopted new technology of the time to create a service centre in Dundee that served London customers. From the humble beginnings of the Spectrum ZX-81, the computer industry grew, especially design and manufacture of games and the world famous Grand Theft Auto range began in Dundee. The discovery of oil in the North Sea brought new need for the wide-access and deep-water docking provided by the port in Dundee, and the city has also moved to provide facilities for the growing renewable energy market. One of the most visible signs of this is the two wind turbines erected at the Michelin factory in 2006. The turbines produce enough power to run around 1,500 homes and have significantly reduced production costs at the factory.

Dundee has also now become a tourist destination. The museum facilities that already existed in the city have been added to with the Verdant Works, which recreates what life would have been like working in the jute industry, and the

Construction work commencing at the Michelin factory, Dundee. (Photo used by kind permission of Michelin UK)

Above and opposite page: The Lemmings Statue depicts the famous video game created by DMA Design, who would go on to create Grand Theft Auto.

The Verdant Works are a former jute mill, now converted to a museum reflecting the life of the jute workers.

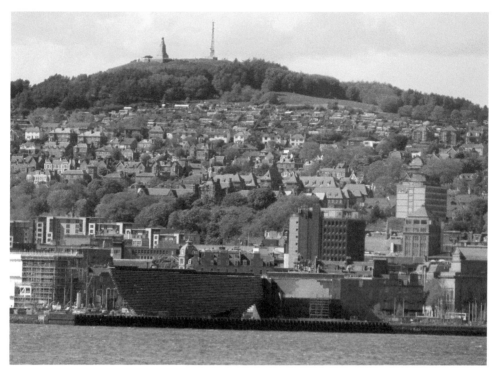

The V&A Museum during construction.

Construction work to create a new footbridge to the new Michelin factory, Dundee. (Photo used by kind permission of Michelin UK)

Ongoing construction work for the new Michelin factory. (Photo used by kind permission of Michelin UK)

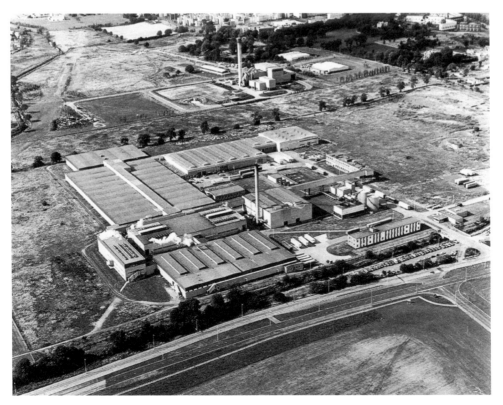

The complete factory in 1972. (Photo used by kind permission of Michelin UK)

The first tyre produced at Michelin, Dundee. (Photo used by kind permission of Michelin UK)

Extension work at the Michelin factory, Dundee. (Photo used by kind permission of Michelin UK)

The wind turbines at Michelin, a well-known landmark.

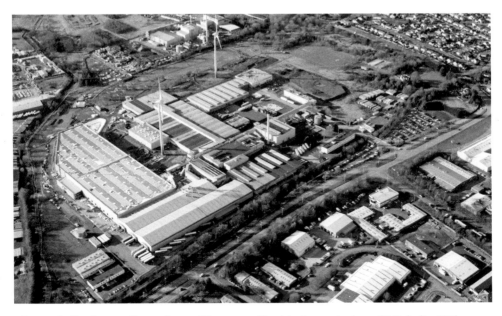

The Michelin factory from above. (Photo used by kind permission of Michelin UK)

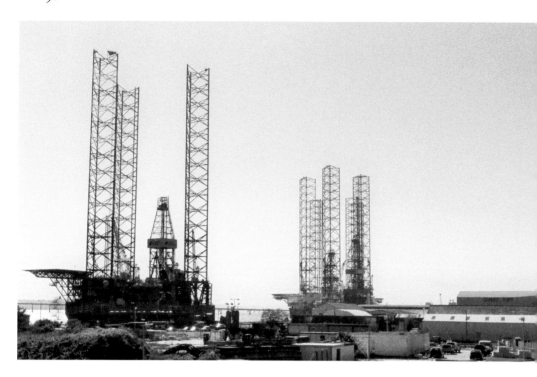

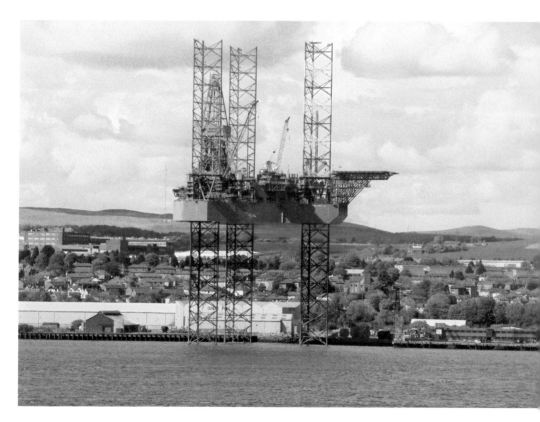

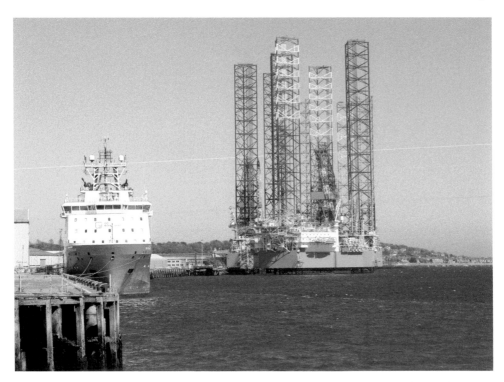

Above and opposite page: Oil rig repairs are a major part of the work at Dundee Docks today.

The submarine memorial at the docks. (Courtesy of Bill Nicholls under Creative Commons 2.0)

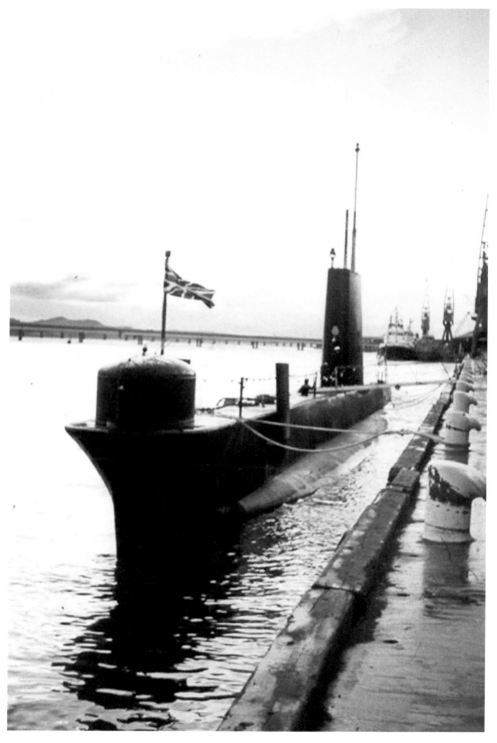

The deep waters of the Tay allow submarines to enter the docks. (Courtesy of Elliott Simpson under Creative Commons 2.0)

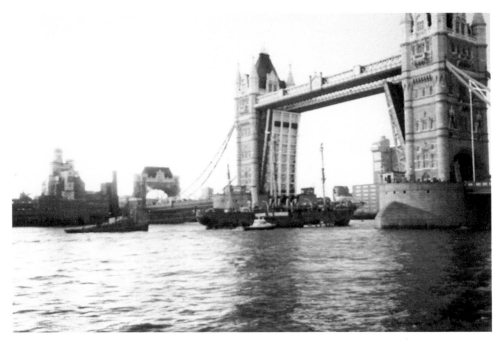

The RSS *Discovery* leaving London to return to Dundee. (Courtesy of E. Gammie under Creative Commons 2.0)

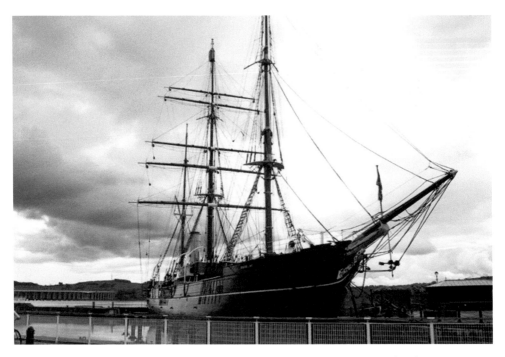

the RSS *Dundee* in its new purpose-built dock in Dundee. (Courtesy of Mike Pennington under Creative Commons 2.0)

RRS *Discovery* was finally brought home and was berthed in a purpose-built dock, becoming the focal point for a museum to Dundee shipbuilding and Antarctic exploration. A £1 billion redevelopment of the Dundee waterfront commenced in 2003, bringing much improved hotel facilities to the city and the flagship V&A Museum of Design, providing an international centre for design in Scotland, the first design museum to be built out with London in the UK. Cruise ships are also able to take advantage of Dundee's port facilities.

With so much work going on around the city it is clear it has a bright future; however, one must also wonder how much of Dundee's historical past remains hidden, yet to be uncovered by the ongoing works.

Bibliography

Books and Publications

Anon, Dundee *Delineated: Or, a History and Description of the Town, its Institutions, Manufacturers and Commerce* (A. Coleville, 1822).

Baxter, J. H., *Dundee and the Reformation* (Abertay Historical Society, 1960).

Mackie, Charles, *Historical Description of the Town of Dundee* (Joseph Swan, 1836).

Miller, A. H., *Haunted Dundee* (Malcolm MacLeod, 1923).

Thomson, James, *The History of Dundee, From the Earliest to the Present Time* (Robert Walker, 1847).

Torrie, Elizabeth, *Medieval Dundee: A Town and Its People* (Abertay Historical Society, 1990).

Various, *Edinburgh Magazine and Literary Miscellany: A New Series of the Scots Magazine*, Volume II (Archibald Constable & Company, 1818).

Websites

Dundee Womens Trail: http://www.dundeewomenstrail.org.uk

The Survey of Scottish Witchcraft, The University of Edinburgh: https://www.shca.ed.ac.uk/Research/witches

About the Author

Gregor was born and raised in the town of St Andrews in Fife. Having been surrounded with history from a young age, his desire to learn about the past was spiked through his grandfather, a master of gold leaf work, whose expertise saw him working on some of the most prestigious buildings in the country, including Falkland Palace. After talking to other staff in these monuments he would come back and recall the stories to Gregor, normally with a ghost tale thrown in for good measure.

Growing up, Gregor would read as many books as he could get his hands on about ghost lore. Going into adulthood, his interest continued and he would visit many of the historic locations he had read about. After taking up paranormal investigation as a hobby, Gregor started to become frustrated at the lack of information available behind the reputed hauntings. He has always felt it is easy to tell a ghost story, but that it is not so easy to go back into a history to uncover exactly what happened, and when and who were the people involved that might lead to an alleged haunting. He made it a personal goal to research tales by searching the historical records to try to find the earliest possible accounts of both what had happened and the first telling of the ghost story, before it was adjusted as it was handed down from generation to generation. This proved to be an interesting area to research, and Gregor found himself with a lot of material and new theories about what causes a site to be allegedly haunted. After having several successful books published about the paranormal, Gregor found himself uncovering numerous forgotten or hidden tales from local history. These were not ghost related, but were stories too good to remain lost in the archives, and he looked to bring the stories for specific towns together to tell the lesser-known history, including often the darker side.

Gregor's first book in this area was *Secret St Andrews*, telling the long and often brutal history from his own neighbourhood, and he has since written both *Secret Inverness* and *Secret Dunfermline*. Having worked for many years 'across the water' in Dundee, he was keen to turn his attention to the forgotten past of this great city.